Creating
MANDALAS

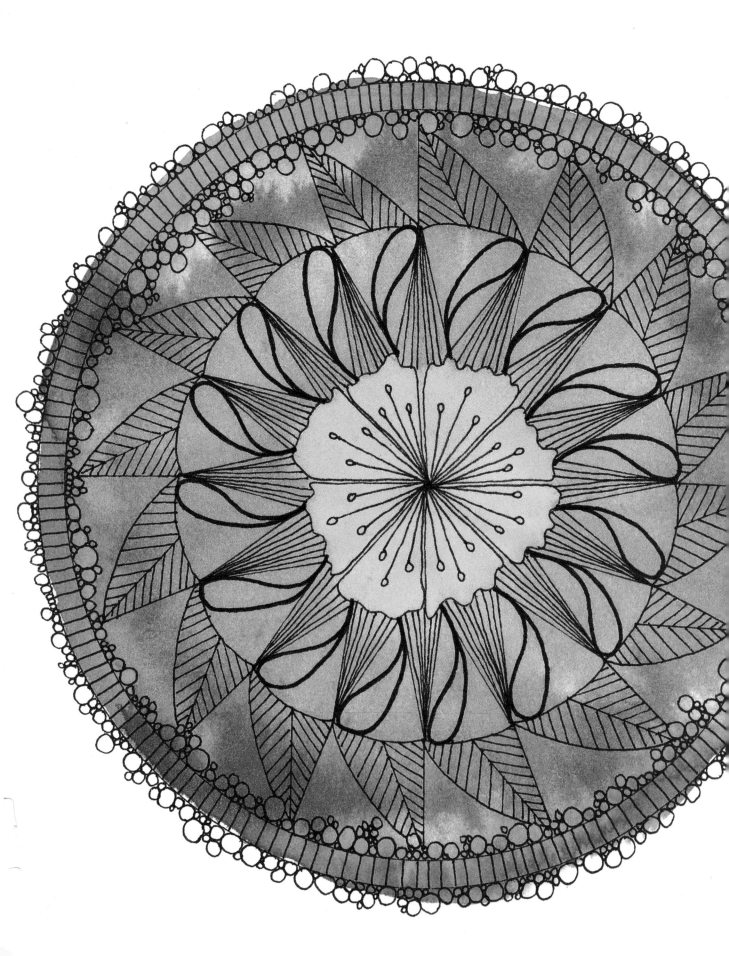

Creating
MANDALAS

How to Draw and Design Zendala Art

Deborah A. Pacé, CZT

NORTH LIGHT BOOKS
CINCINNATI, OHIO
www.createmixedmedia.com

Contents

What You Need

General supplies:

Colored card: gray, navy blue, tan, white, black

Compass

Erasers

Gold leaf

Gold metallic gel pen

Mounting adhesive, double sided

Paper, bristol, 6½" (17cm) square

Paper tape

Pencils, no. 2

Pens, Pigma Micron 01 (.25mm) and 08 (.5mm) black

Ruler

Sakura Gelly Roll pen, white

Scissors

Spirograph

Stencil template blanks

Tracing paper

White chalk pencil

Optional supplies:

Bone folder

Craft knife

Glue stick

Permanent marker

Protractor

Stencil cutter

Watercolor paintbrush

Watercolor pencils

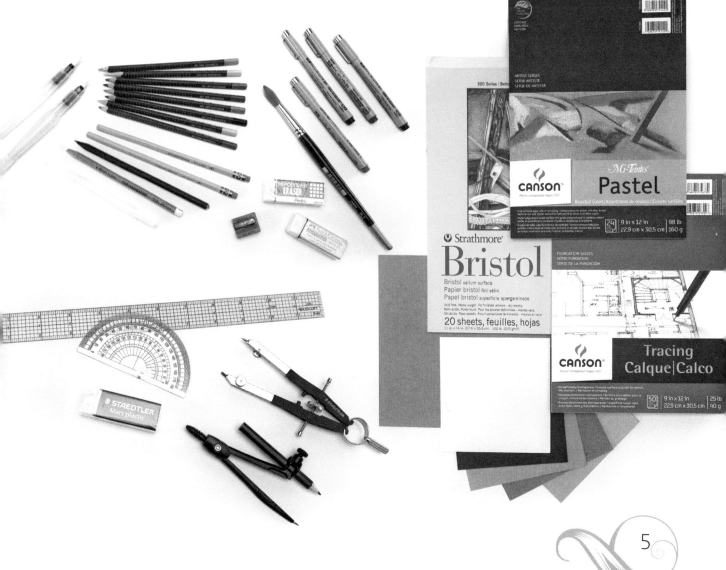

Introduction

The art of making mandalas is less about drawing and more about slowing down and opening up to your inner creative flow. You do not have to be an artist. There is no need to know how to draw. All you need to make a mandala drawing are some simple everyday tools and a little effort. Can you create a circle using a compass and pencil? Can you draw a line? Can you repeat patterns? Then you can create your own mandalas.

It is important to have fun and not to stress when creating your mandalas. Beautiful mandalas are formed when we just go with the flow and let the patterns happen. If you make a mistake, so what? Learn to incorporate it into your design, giving your design character. Happy accidents are in some of the mandalas that I have created, but you do not see them because instead of stressing over it, I just incorporated them into my designs, sometimes intentionally repeating that little happy accident. What did I get? An unexpected design that worked. If you worry that your lines are not exactly straight, or your circles are not perfectly round or all the same size, you will not enjoy making your mandala. Let go and see what happens. You might be surprised.

In this book you will learn the basic steps to create a mandala and how to make your mandalas uniquely you. Through projects based on my own designs, I will show you step-by-step how to create different mandalas, and you can give it a try on practice pages that are right in the book. There are also many templates you can try and a gallery of mandalas I have drawn to inspire you. You will learn how to add color to them, how to find shapes and designs that are all around you, and most importantly, I hope, you will learn how to relax and just let yourself play.

As you create your mandalas, you will build confidence and develop your own unique creative voice. I hope you fall in love with mandalas as I have, but most of all, I just want you to have fun and enjoy the process of making these personal little works of art.

— Deborah

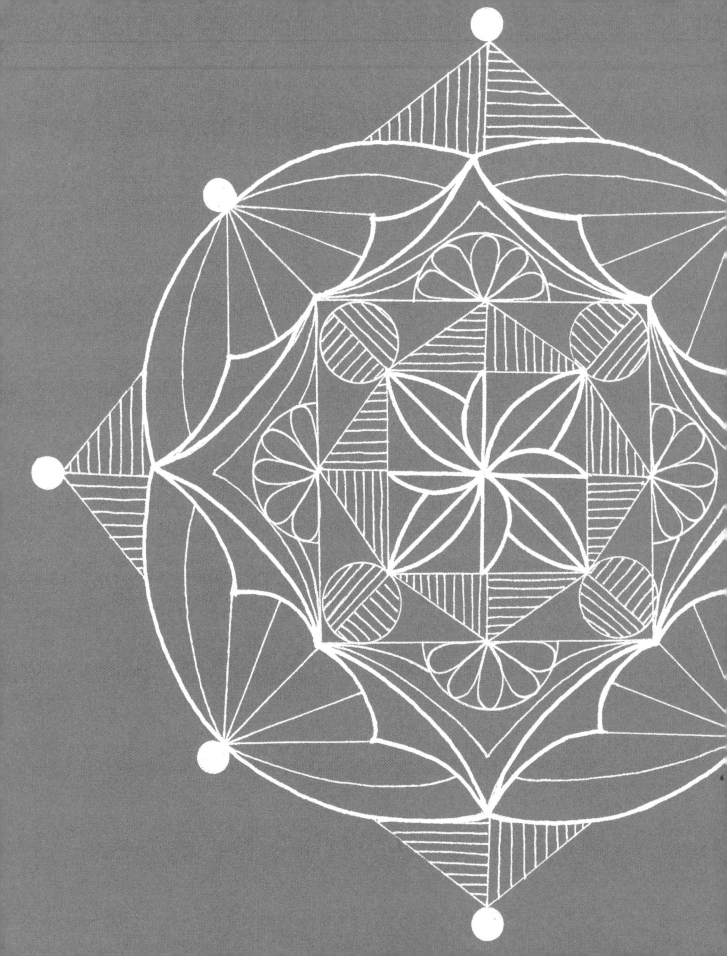

CHAPTER 1

GETTING STARTED

Mandalas are created from the center out, whether it is with a dot or circle. The substrate you draw your Mandala on is usually white paper, drawn upon with black ink or pen. However, that being said, as you become more familiar with creating mandalas, you can start to explore and go beyond the usual. Mandalas are easy to draw. With a little bit of imagination and practice, you can take your mandalas to any level that is comfortable for you. They can be as simple as a couple of lines, circles and patterns, or complex, with fine lines, a series of concentric circles and detailed patterns. Your mandalas are an expression of you, so remember, whatever you choose to do, enjoy the process.

Supplies

No. 2 pencils—A no. 2 pencil is best to work with when drawing lines with a pencil. It is easily erasable; you can make faint pencil lines and still see your lines. It does not leave a mark on your paper like some of the harder leads do. I have a favorite woodless graphite pencil that I like to use. It has a jewel tip that makes me happy every time I use it.

Erasers—I have several erasers I like to use, made by Faber-Castell, Staedtler and Pentel. In my opinion they all work equally well, but I do tend to favor the Faber-Castell. The Faber-Castell is dust-free and erases cleanly. It's a matter of preference.

Pigma Micron pens 01 (.25mm) and 08 (.5mm) in black—Why Pigma Micron pens? Because they are permanent and they do not bleed. Even when you use the large-tip (.5mm) pen to darken a section, it does not bleed through. I like this because I do not have to worry about putting another piece of paper underneath my project. If I use pencil lines, I can erase them without worry of smearing the ink.

Pigma Micron pens 01 (.25mm) and 08 (.5mm) in blue and brown—As with the black Pigma Micron pens, the colored pens are permanent, do not bleed and have the same good coverage.

Sakura Gelly Roll pen in white—This pen is excellent when drawing on black or dark papers. The white ink shows up well. You can get a fine or heavy line with this pen, depending on the pressure you apply when drawing.

Strathmore bristol paper pad (vellum surface)—I use this because of the smoothness of the paper. I have, however, used Strathmore smooth bristol paper. It has a little more texture, but both work equally well. I prefer the smoothness of the vellum; it's just my personal preference.

Paper

The sky is the limit! In this book I use bristol paper, cardstock, scrapbooking paper and tracing paper. But you can use any paper you want to use or that you have on hand.

Colored papers—I like to use a variety of papers to create my mandalas. No one says you have to use just white. I also use colored cardstock or scrapbook paper. Some of my favorite colored papers are the Canson Mi-Teintes drawing papers. They come in three different variety packs: pastel, earth tone and gray tone. I not only like the colors in these pads, but I also like the texture of the paper.

Tracing paper—In this book you will make a paper snowflake to help create a mandala design. I find that tracing paper is thin enough to cut through layers of folds easily, yet sturdy enough to hold up to the cutting without falling apart.

Compass—A compass is a must-have for creating perfect circles. You can also get a compass that has a latch to hold a pen. My favorites are pictured on the next page. I've had them forever.

Ruler—Generally a ruler is used for measuring, but I use mine to help me draw straight lines and not so much for measuring. Shown is my all-time favorite ruler and I am lost without it. I like that it is clear and I can see my lines underneath.

Protractor—A protractor is another tool to have in your arsenal of supplies. It is very helpful when you want to draw a multitude of evenly spaced lines around your mandala.

Stencils—Stencils are a great jumping-off point when creating your mandalas—a great beginner tool or for when you are stuck and don't know where to start. You don't have to think too much about the design.

Spirograph—This fun contraption that first came out in the United States in 1965 is used for making various circular designs. It is ideal for making mandalas.

Watercolor pencils—For adding color to mandalas, I prefer to use watercolor pencils even if I am not going to use water on them. With watercolor pencils, you can blend your colors together very easily using a blending stump (I use cotton swabs; don't laugh). When shading, I can easily blend the color out so I'm not left with a sharp line.

Watercolor paintbrush—I like to use a Niji Waterbrush. It has a fine point at the tip, even on

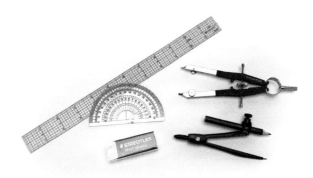

Compass, Protractor and Ruler
These are all essential parts of my toolkit. The compass allows you to draw perfect circles, the protractor ensures evenly divided spaces, and the ruler helps make straight lines that are truly straight.

the largest brush size. I can get right to the edge of my design without worrying about going outside the line. It has a reservoir for water, so I don't have to worry about accidentally spilling a container of water on my work.

Mounting adhesive—This is used to adhere gold or silver leafing to create an illuminated letter mandala.

Gold or silver leaf—This is used to illuminate your designs. It comes in sheets and flakes.

Metallic pens—These can be used to enhance any gold or silver leaf you apply to your design.

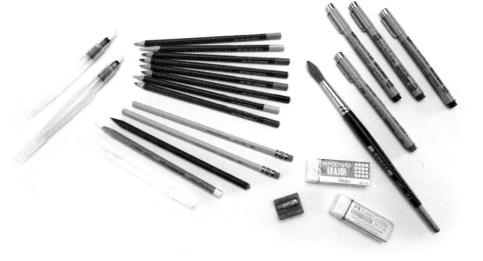

Pens, Pencils and More
Pencils are perfect for drawing your base lines and can be easily erased when no longer needed, and nothing is better than a Pigma Micron pen for tracing over pencil lines. Gelly Roll pens and watercolor pencils are my favorite for coloring mandalas, but there are plenty of other options out there as well.

Visit CreateMixedMedia.com/creating-mandalas for extras.

What Is a Mandala?

A mandala is an artwork of intricately drawn patterns contained within a circular or square shape. The word *mandala* is a Sanskrit term that means "circle" or "discoid object." Circles appear in nature (flowers, snowflakes, sun, moon, etc.) and in man-made architecture, and circles are believed to help individuals focus inward.

The basic form of most mandalas is a square with four gates containing a circle with a center point. Mandalas can contain both geometric and organic forms. They can also contain recognizable images that carry meaning for the person who is creating them.

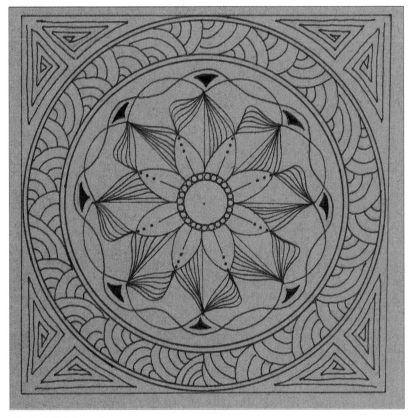

Circle Within a Square

I used gray tonal paper by Strathmore and a black pen to draw this mandala, *Tile*, which shows a circle within a square. There is a simple pattern in the center, and as the design expands outward, the patterns become more intricate. Sometimes I like to leave a lot of space in my designs and other times not, as in this one, which has lots of patterns throughout.

I knew as soon as I was finished with this mandala that it looked like a tile. I would like someday to have tiles made using this mandala pattern to use in my home in the kitchen, bathroom, or on the floor. I can see using this as an accent piece.

TELL A STORY

After you draw your mandala, put it aside and look at it the next day when your eyes are fresh. Does the mandala you created tell you a story?

Sign up for our FREE newsletter at CreateMixedMedia.com.

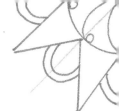

How to Create a Mandala

Here are some basic guidelines and suggestions to help you begin creating mandalas. This is the simplest way I know to start a mandala. The basic lines give you a starting point, but please feel free to start your mandala any way you like.

Choose the type of paper you want to work on and the size. I usually work with a square about 6½" × 6½" (17cm × 17cm), but you can work on any size that is comfortable for you.

Draw linear guides and establish your center. I start a mandala by drawing straight lines on the paper diagonally from the corners and then across (vertically and horizontally), lightly in pencil. This gives you a center point. With a pen, place either a dot or a small circle in the center. This is your beginning point.

Draw a circle. From the center point, using a compass, draw a circle (I do not usually measure; I just put something down to get me started). If you already have an idea for your center design, you can make your circle larger or smaller to accommodate your design.

Start drawing lines, patterns and more concentric circles until you have a design you like. Always concentrate on the center of your mandala. This

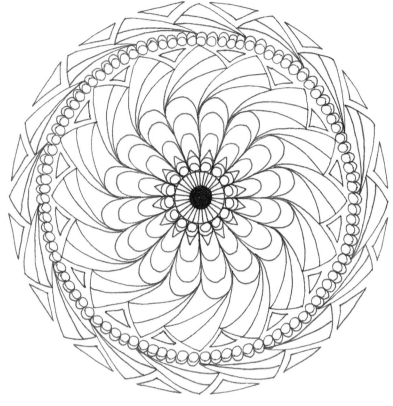

Repeating Patterns and Lines

When I was growing up, my mom had a ringer washer. You could actually see the clothes swishing back and forth. This mandala reminds me of that. The mandala was drawn using repetitive patterns and lines. I repeated the pattern around the center flower on the outside of the circle. Having them go in opposite directions made it look like the mandala was moving this way and that way, so I titled this design *This Way and That Way*.

gives you an anchor point to focus on as your mind wanders. That being said, I do not always start in the center. Sometimes I work from the outside in because I can visualize the outside of the design before anything comes to mind for the center. Does that make a difference? For me, it does not.

MAKE A SKETCHBOOK

While working on this book, I made a mini 5" × 5" (13cm × 13cm) sketchbook, and on each page I drew a circle and some diagonal and cross lines. When I got an idea for a mandala, I worked out the pattern in that sketchbook.

Other Ways to Make a Mandala

There are many ways to make your mandala, and no one way is better than another. It is up to you to decide which way works best for you, depending on what (and how) you want to create. I told you how I like to start, but here are a few other options that I sometimes use and that are very helpful when creating mandalas. In all of these, the lines are drawn lightly in pencil. You can then erase the lines or go over them with pen depending on whether you want them to show in your final work.

Concentric Circles

Instead of drawing guidelines diagonally and across, find your center point and then, with a compass, draw a series of concentric circles. You can draw in as many or as few circles as you want to work with, and they can be as close or far apart as you like. This is great if you want to draw patterns with no particular design in mind.

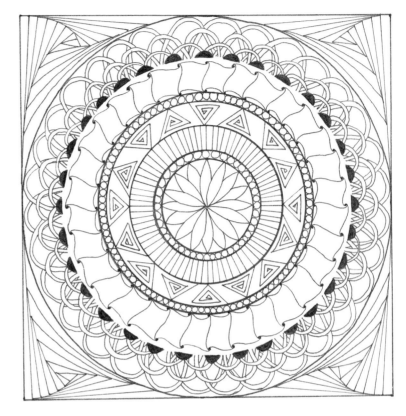

Concentric Circles

Tribal was made in a workshop I taught on mandalas. I wanted my students to try many different patterns and learn how to put them together. When drawing this, some used a compass; others used a circle maker, and one individual created the concentric circles by using differently sized round items. You can draw your mandalas using whatever you have on hand. After this mandala was finished, it looked like a tribal warrior's shield, hence the name.

Sign up for our FREE newsletter at CreateMixedMedia.com.

Grids

Grids are great if you want your design to be more geometric. The grid also helps in placement and ensures your patterns and designs are evenly spaced.

Grids

I originally drew this design in colored pencils, marker and metallic pens in my sketchbook, but when I redrew the mandala for this book, I decided not to fill it in with color. After seeing it in black and white only, I liked the look better. Colors seemed to make it too busy. In *Underneath the Bamboo Tree* the center design looks like a table and chairs underneath umbrellas with bamboo trees surrounding it for shade.

Lines

A series of lines drawn from the center outward is a great way to begin. You can create many fun patterns that will be evenly spaced, such as flower petals, stars, intersecting boxes and so on. You might end up with a design that looks like a mariner's compass. If you drew an eye in the center, then the lines would be removed.

Lines Are the Star
Drawing on a black or dark background with a white pen calls for either more detail or more lines. This mandala is very open, but the multiple lines in the center set off this design nicely. The name, *Glow*, came about because of the glowing effect the closely drawn lines give.

Sign up for our FREE newsletter at CreateMixedMedia.com.

Freeform

The point of freeform is just that: a form that is created freely. Freeform mandalas can be contained in a particular space, or the space you will be working in can be freeform. It is up to you and your imagination.

Be Free

I don't always know what I am going to draw ahead of time when creating my mandalas. I just start to make a mark and let the inspiration come through as I draw my patterns. The same is true for this mandala, *Queen for a Day*. I started with a small dot in the center and then went with my go-to pattern, a leaf shape, but here I modified the shape of the leaf by only drawing one side and then the other and shaped it in the form of a triangle. When the center design was done, I used a favorite finishing pattern, the swirl circle, except I did not end there. I drew folded feathers in the middle circle, and for the outer design I drew large and small curved triangles, and then I added some circles to the tips. When the mandala was done, it took the shape of a crown.

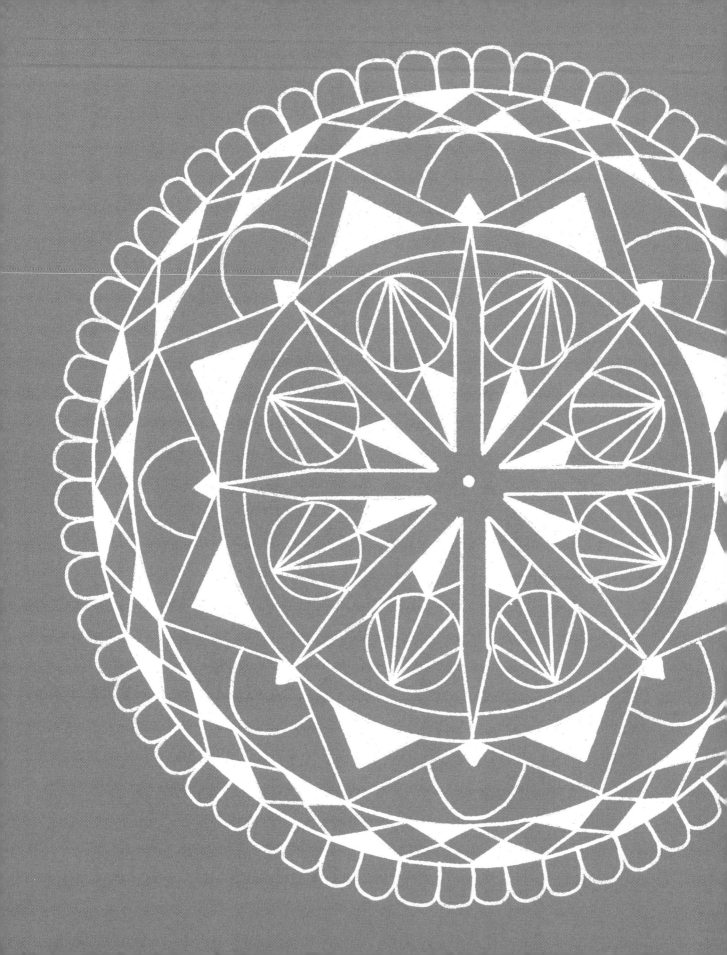

TYPES OF MANDALAS

This chapter will show you different approaches to developing your mandalas. Not all mandalas have to be black and white or drawn with a black pen. I hope to show you how to have fun exploring different options when creating them, including adding color or using colored paper. Each of these mandalas will increase your knowledge and show you the possibilities. I hope this chapter will help you "think outside the box," so to speak, and come up with your own ideas.

I have grouped these particular mandalas together because to me, these are like stepping-stones, going from one step to another, giving you knowledge and ideas that can be incorporated into your next design. Pick and choose combinations you want to put together. Experiment! Now let's get started.

Bold and Dramatic

Bold and dramatic mandalas really make a statement. They are strong, fearless and daring. They are strikingly different, clear and distinct. Darkening lines can also change the mood of your mandala. If you know your design ahead of time, you can draw your darkened lines in as you go, but I suggest that you wait until you are finished with your design. Then take a step back and see what shapes or designs you want to enhance. Do not darken in all the lines at once. Doing this may not give any distinction to your patterns. Throughout my designs I only use darkened lines where I want either separation or a particular design or pattern to pop.

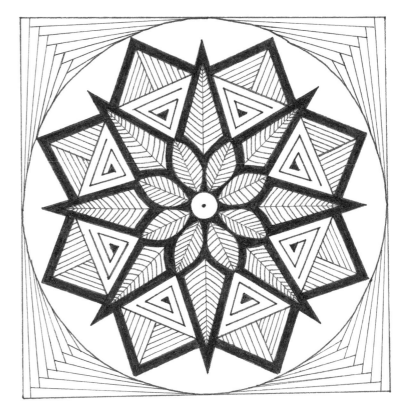

SELECTIVELY DARKEN

After drawing your design, step back and take a look at it for a second or two. If everything seems to mesh too much, try darkening some of the lines in your design. Remember, not every line has to be darkened. If you are not sure, use a thicker-tip pen and just go over some of the lines. That may be all you need.

Darkened Lines for Emphasis

Mandalas can really make a statement as with *African Rose*. When I created this, I started with petals and then added lines to the petals, creating leaves (my go-to pattern). I made star points next, and like the petals, I added lines to make them into leaves as well. With this mandala, lines spoke to me, so I just kept adding lines and more lines. When I finished my mandala, everything seemed to run together with no distinction. So with a black .5mm Pigma Micron pen, I darkened and thickened the lines in between the petals and along the outside edge of the mandala design. Once I did that, everything popped!

Light and Airy

Sometimes the simplicity of a design can really make it stand out. You do not always need dark lines to separate or enhance your designs or patterns. Leaving open spaces can do just that. The white space in between each pattern can really make or break a design. What do I mean by that? Too much space and your mandala will look empty or flat. Not enough will make the pattern mesh without any distinction. You need a balance between the two. If your spaces look too open, add another pattern. Your mandalas do not need to be completely filled with patterns to look beautiful.

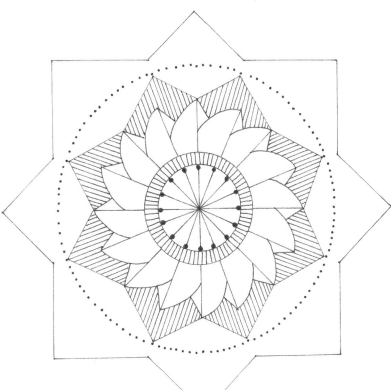

Simplicity and a Nonsolid Line

I think the simplicity of this particular mandala design really makes it beautiful. When I was creating *Wagon Wheel*, I did and did not have an idea in mind—I knew some of the patterns I wanted to use, but not all. I knew I wanted to use the spokes in the center and the scoop shapes. After I had all my patterns drawn in, I wanted to add a circle. However, I did not want to add a solid-lined circle, so I experimented by drawing dots around my center design and liked the way that looked. It still did not look finished to me, so I drew a simple starlike shape around it and left it at that.

DON'T OVERDO

As you are creating a design for your mandala, you do not always have to add a lot of patterns. Do not overdo it. Sometimes less *is* more. Simplicity can have a profound effect on your mandala and add to its beauty.

Colorful

To these mandalas I added touches of color using either watercolor pencils or watercolor paint. A few of us have difficulty with shading, but using watercolor pencil or paint can help you ease into shading. You do not need to know which side to shade or where the shadow is coming from, just add a bit of color. You can either outline your patterns with watercolor pencils as I did with *Gelly-Fish* or you can just go for it, paint first, and add patterns later, as I did with *Birth of a Flower*. With this particular mandala, I think having an idea of what you will draw ahead of time helps. As you draw your mandala, you will get a feel of what color you would like to use in your design. If you are painting first, remember some colors will turn brown when mixed together. Keep this in mind when you are putting color down first.

Special Considerations for Adding Watercolor

Creating your mandala using watercolor paper and paint can be done in two ways. You can either lay the watercolor paint down first and then add your patterns, or you can draw your patterns first and add watercolor paint afterward. Also, watercolor pencils can be used instead of watercolor paint.

Sometimes I like to use watercolor pencils for shading instead of graphite. The colors

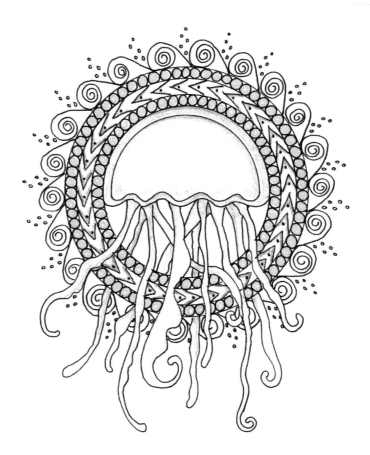

Touches of Color

If you want to ease into adding color to your mandala, *Gelly-Fish* is a good example to start with. I love the shape of jellyfish, and so that was the inspiration for the start of my mandala. I kept my jellyfish very simple and added outside patterns to make the mandala more interesting. When I finished, I used watercolor pencils to color here and there, adding just a touch of color.

are easy to blend and it adds just the right pop of color. However, I do not always use water with my watercolor pencils—actually, most of the time I do not. When I do add water, though, it is important to note that the more water that is added, the more the pencil looks like traditional watercolor.

I always use watercolor paper when using paints and pencils. This probably isn't necessary if

you are using only pencil or just a small amount of water, but if you use a lot of water, paper that isn't specifically made for watercolors could buckle. Plus, depending on the type of watercolor paper you use, you can get a lot of texture when adding watercolor. I usually prefer cold-pressed watercolor paper. However, hot-pressed watercolor paper has a smoother surface, which you may like better.

Sign up for our FREE newsletter at CreateMixedMedia.com.

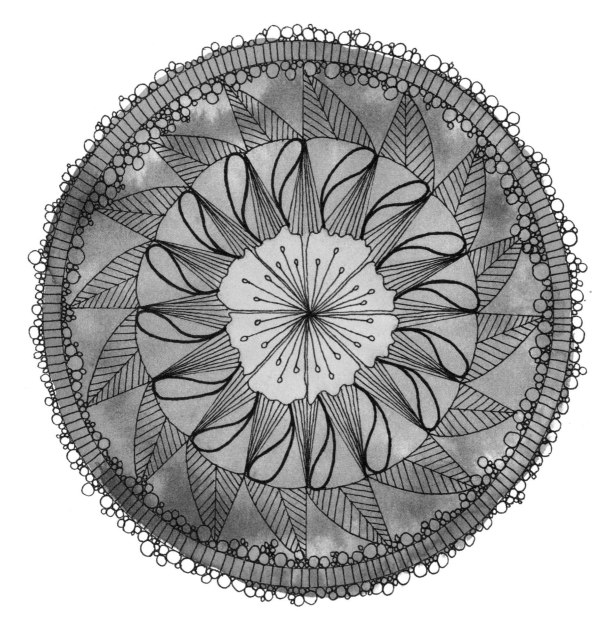

Full Color

For *Birth of a Flower*, since I did not have an idea in mind when I applied the watercolor paints, I started with lighter colors first in the center and gradually got darker with my colors as I moved outward. I let the shapes speak to me, drawing in my patterns and using the colors as my guide.

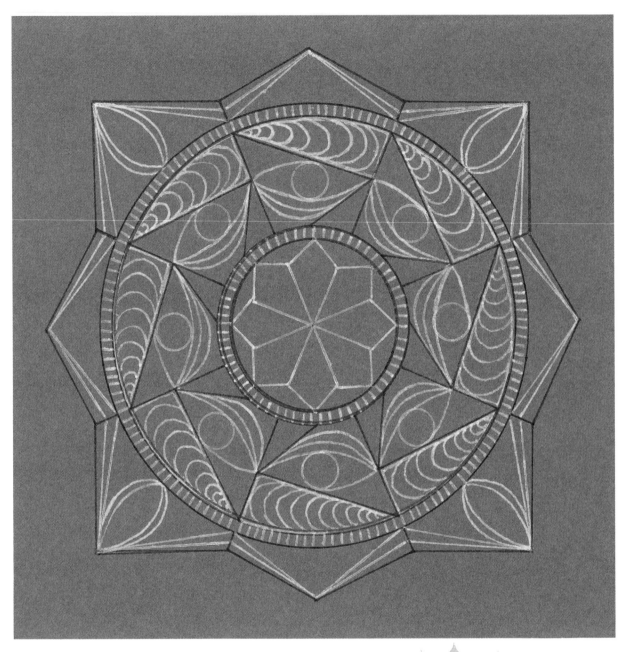

Starting on Colored Paper

Who says you have to use white paper to create
your mandala? I love drawing mandalas on different
colored papers as I did here with *Pearls*. The paper
I used was Mi-Teintes Pastels by Canson. I used a
white Sakura Gelly Roll pen to draw my patterns and
then outlined with a blue Pigma Micron pen.

REPEAT, WITH DIFFERENCES

Try drawing the same mandala
using different colored paper
with different color pens/pencils.
See how although the design
may be the same, the look
and effect you get can be
quite different.

Sign up for our FREE newsletter at CreateMixedMedia.com.

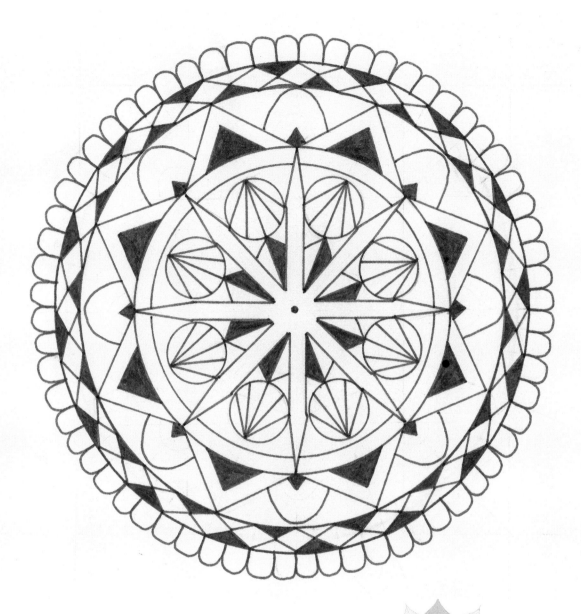

Drawing with Colored Pens

Usually when I draw using a colored pen, I use a colored background paper. I used white paper to draw *On Point* to see what the blue pen would look like against a white background.

I started with a tiny dot in the center, and I used my diagonal and cross lines that I usually draw first as my guidelines for the center spokes. I kept mostly with the idea of triangles and points. When I completed this mandala, all the points jumped out at me and, yes, they were all on point.

TRY A SERIES

When creating your mandala with colored pens on a white background, try working in a series. Draw the same mandala using different colored pens, pencil and/or markers, and see how each color changes the look.

Whimsical

This section is all about letting go and having fun. These mandalas are not your traditional mandalas. I stayed with the basic form, but I had fun with the patterns. You can combine patterns with shapes, repeating them as you work your way out, as I did with the *Chicks* mandala. Pick a pattern, play with it and change it up a bit. Stay with the basic shape of the mandala, using either a circle or square or both, and work your patterns in them. This way you keep the general shape of the mandala but still have fun with the patterns. Try modifying your patterns and see what new designs you can incorporate into your mandala.

Creating Outside the Lines
I did not finish this mandala, but I want to give you an idea of what you can do using a basic circle and lines. (I enjoy playing around with simple shapes, and it just so happened that a face appeared to me!)

LET GO
When you create a whimsical mandala, have fun with it. This is where you can really let yourself go and let your imagination take over. Instead of traditional patterning, see what you come up with.

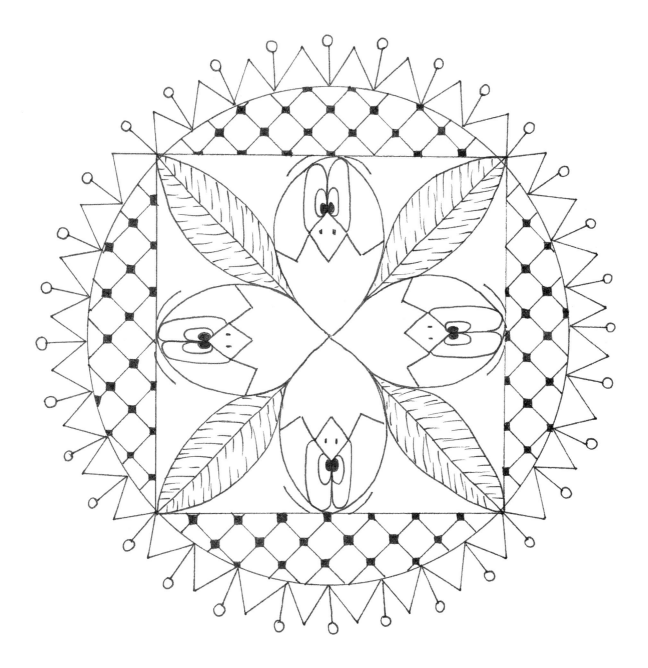

Lighten Up

Being serious all the time can be a bit boring, and the same applies to creating mandalas. I do like to have a little fun and add a bit of whimsy when drawing some of my mandalas now and again, as with *Chicks*. I followed the same concept, starting in the center and working around and outside. This time, instead of having a circle, I used a square within a circle, but you can use a circle within a square.

Freeform

Now we are getting to the part where anything goes. Although you can start with the basic shape of a mandala, as with *Mr. Pacino*, you do not have to stick to that shape, whether it is a circle or square. With the first example, I made the mandala freeform, adding basic patterns. With *Mr. Pacino*, I kept the basic shape and made the design freeform. I could have made this more traditional by dividing it into four segments and repeating the pattern four times as with *Chicks* (on the preceding page), but I liked the idea of just letting go and letting my design be what it wanted to be. With this particular type of mandala, the sky is the limit, but keep in mind the basic form of the mandala and/or patterns. Try not to get carried away to the point where your mandala ends up not being a mandala any more.

Freeform Shapes
This example is not so much about making the inside patterns freeform, but making the mandala shape itself freeform and adding patterns inside.

STAY TRUE TO YOU

This is *your* mandala. Create it any way you want. Use one or both of the freeform approaches shown here, a combination of the two, or come up with your own unique approach. As long as *you* like it, that's all that matters.

Sign up for our FREE newsletter at CreateMixedMedia.com.

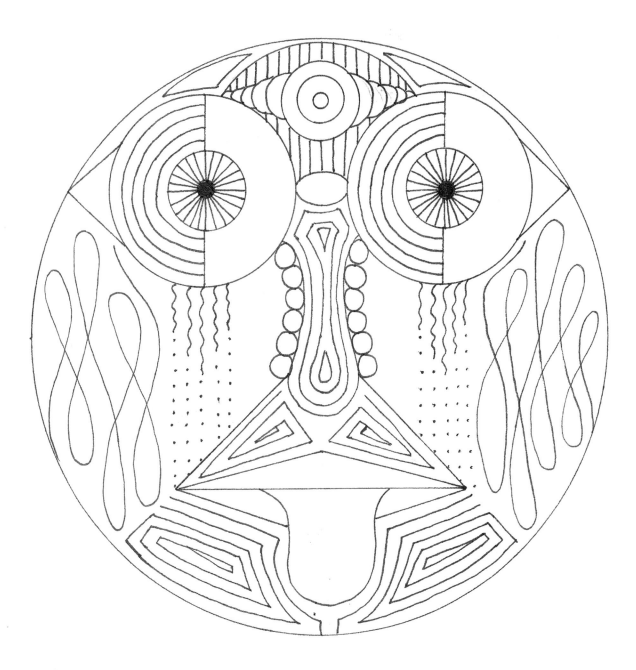

Freeform Patterns

As with other mandalas, there is repetition and symmetry in *Mr. Pacino*. I just took a few more liberties with this example. The design is more vertical, and instead of drawing my patterns all the way around, I drew them from side to side. I could have made it more traditional looking by adding another concentric circle around it and adding more patterns, but to me, it would not have been as freeform, which is what I was going for.

Visit CreateMixedMedia.com/creating-mandalas for extras.

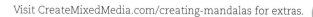

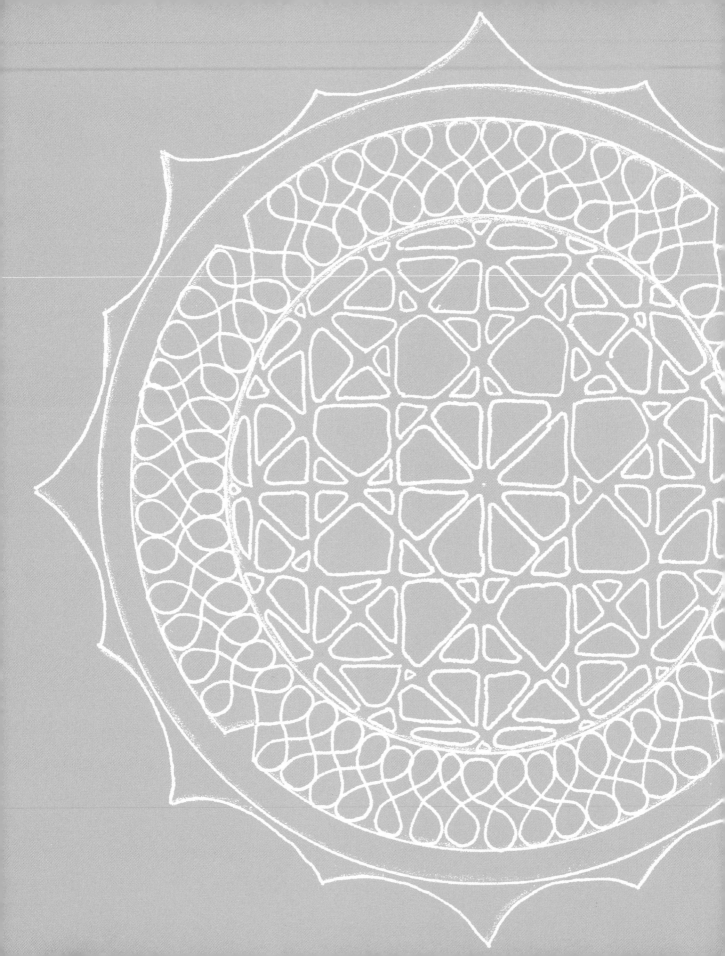

CHAPTER 3

BASIC MANDALA PROJECTS

The mandalas in this chapter start in the center and work outward. As you progress, each mandala will be a bit more complex. In the last one you will work in a square. I have added a mandala using colored paper, but you can work this one on white paper if you like. I give you a bit of variety to help you get the feel of creating different mandalas.

As we create the following mandalas, you will learn how to add lines and patterns one step at a time. These mandalas are fairly simple to create, with fewer steps needed to finish them.

PROJECT
River Flower

River Flower was one of the first mandalas I created for this book. As you can see, it is a very simple design using mostly lines. The name *River Flower* came about because of the squiggly lines; each one looks like a river going through the flower.

SUPPLIES

Bristol paper, 6½" (17cm) square

Compass

No. 2 pencil

Pigma Micron pens (black): .25mm (01) and .5mm (08)

Ruler

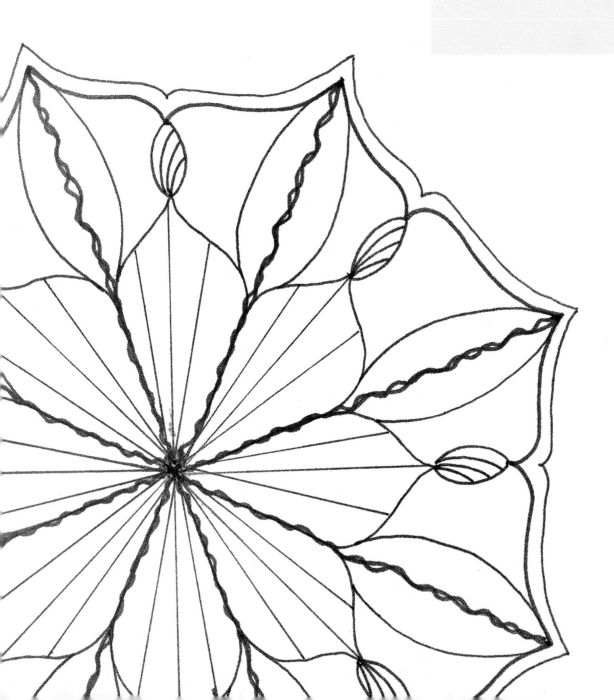

1 With a pencil, lightly draw lines diagonally and across as shown. Using a compass, add a 3" (8cm) diameter circle and a 5" (13cm) diameter circle.

2 Using the black .25mm pen, draw flower petals from the center point to the first drawn circle. Use every other line for the center of each flower petal, and bring each tip to a point. Draw a line down the center of the petal and on either side of the center line.

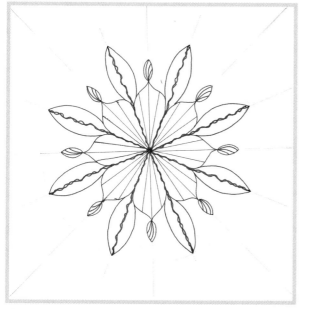

3 Draw leaves between the petals with each point touching the outer circle. Using the .5mm Micron pen, draw a dark wavy line from the top of each leaf down the center. Repeat to make a second wavy line. Draw a flame shape (with 3 curved lines inside each) on every petal tip.

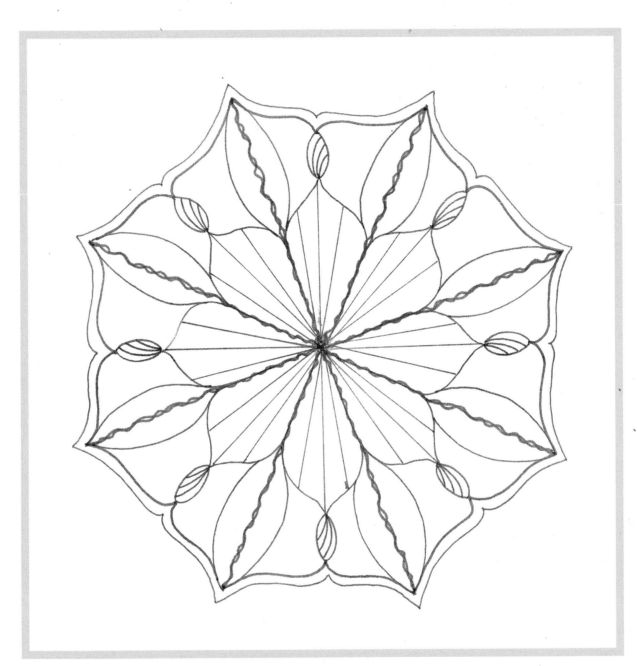

4 Using the .5mm Micron pen, connect the leaves and flames with a dark, slightly curved line. Then switch to a .25mm Micron pen and outline the entire mandala with a second line. Erase all pencil lines.

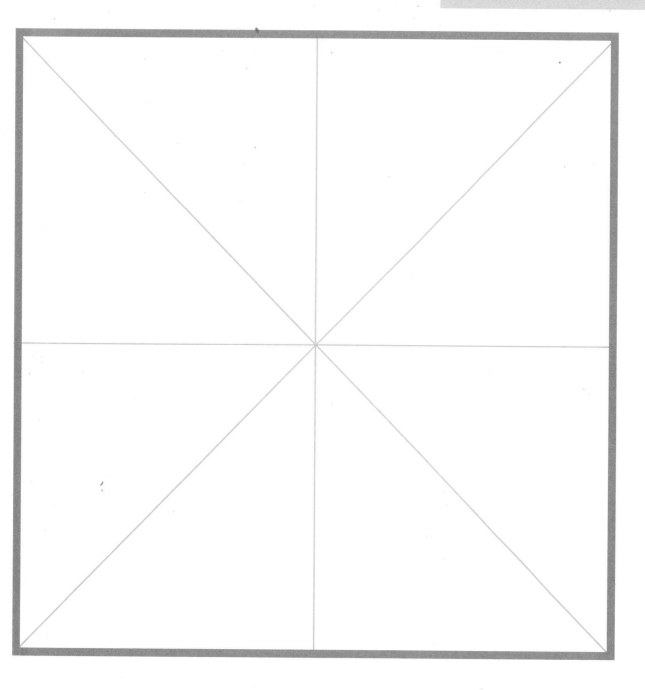

PROJECT
Cobblestones

Cobblestones is another simple mandala design, but the center of the design is a little more complex. It uses simple lines, but I have curved and shaped them. When I completed the pattern in the middle, it looked like cobblestones.

I usually do not have an inspiration when I draw my mandalas, but while visiting my grandchildren one day, I noticed a clock hanging on their wall. This is what I took from that clock.

SUPPLIES

Bristol paper, 6½" (17cm) square

Compass

No. 2 pencil

Pigma Micron pen (black): .25mm (01)

Ruler

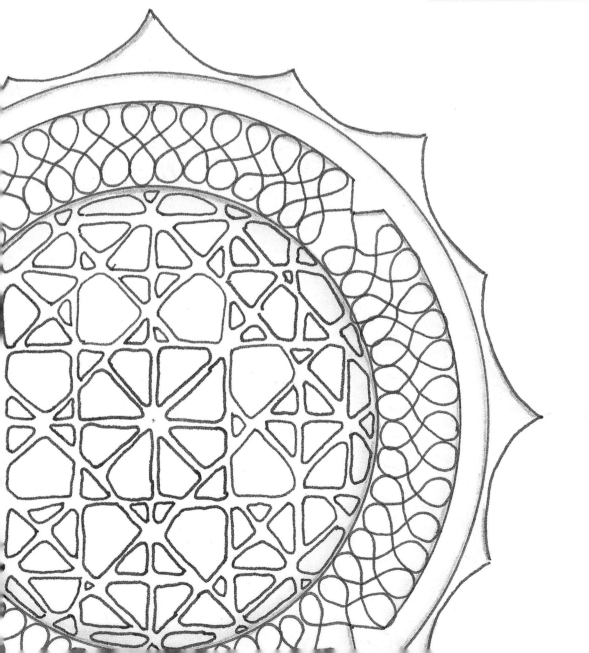

1 With a pencil, lightly draw lines diagonally and across. Using a compass, add 3 concentric circles that are 2½" (6cm), 3½" (9cm) and 3¾" (10cm) in diameter.

2 Draw grid lines lightly with a pencil in the center circle, diagonally and across. With the black .25mm pen, draw over the pencil lines on the first circle, the second circle (leaving about a ¼" [6mm] gap between each diagonal line), and the outer circle.

3 Still using the pen, draw around each triangle shape in the center circle, rounding the corners and leaving a slight gap between each triangle as shown. Draw a V shape at each gap on the second circle.

ADD SHADING FOR INTEREST

Try using a colored pencil (instead of graphite) to shade your mandala around the outside of the center pattern. It will not only make that center pattern pop but also add a bit of interest.

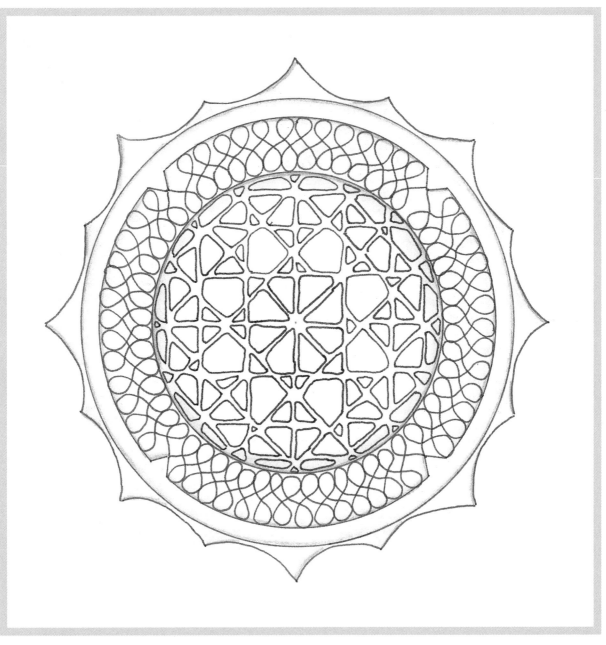

4 In the space between the first and second circle, draw connecting figure eights, starting and stopping at each V. Embellish the outer circle with peaks and valleys. Erase all pencil lines.

PROJECT
Untitled

In this drawing we switch our pen from black to white and our white paper to navy blue. I love working with colored paper and this one is no exception. The look of the white pen against the dark paper makes the design really stand out.

Every year I go to the Pageant of the Masters in Laguna Beach, California. There they have a free printmaking booth. You create a design on Styrofoam, pick your paint color, and they print it for you. This is what spilled out of me. To re-create this, I used navy blue paper and a white Gelly Roll pen.

SUPPLIES

Compass

Navy blue cardstock, 6" (15cm) square

Ruler

Sakura Gelly Roll pen (white)

White chalk pencil

1 With the chalk pencil, lightly draw lines diagonally and across. Using a compass, add 3 concentric circles that are 1½" (4cm), 2½" (6cm) and 2¾" (7cm) in diameter. Draw a small circle in the center using the white Gelly Roll pen.

2 Still using the white Gelly Roll pen, draw leaf shapes using the diagonal and cross lines as a guide (center a leaf on each line, around the smallest circle). Then go over the second circle with the pen. Now draw scallops around the circle. Draw circles on top of the scallops, and add a dot in the middle of each circle. Go over the third and fourth circles with the pen.

3 Draw lines between the third and fourth circles, going all the way around. Now draw a zigzag line around the outer circle.

TIP

Sometimes as I am creating a mandala, I already know what I am going to name it, and sometimes a name comes after it is complete. *Untitled* became the name of this particular mandala because for the life of me, I could not think of a name for it. Don't stress over a name!

Visit CreateMixedMedia.com/creating-mandalas for extras.

4 Draw a line extending from the dip in each zigzag and embellish the ends. Erase all chalk lines.

Sign up for our FREE newsletter at CreateMixedMedia.com.

Shutes & Ladders

Here we are starting to add not only more lines but a bit more patterning and embellishments, as with the previous mandala *Untitled*. After completing this mandala, I noticed the lines around the half circles looked like laddered parachutes. The circles and the triangles looked like people holding on, floating from the parachutes—hence the name, *Shutes and Ladders*.

SUPPLIES

Bristol paper, 6½" (17cm) square

Compass

No. 2 pencil

Pigma Micron pen (black): .25mm (01)

Ruler

1 With a pencil lightly draw lines diagonally and across. With a compass draw 3 concentric circles that are 1¼" (3cm), 2" (5cm) and 2¼" (6cm) in diameter. Go over the circles with the black .25mm pen.

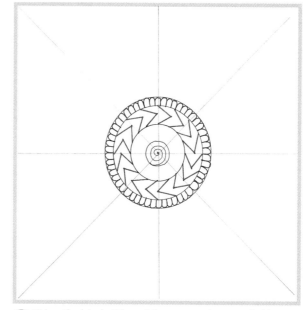

2 Using the black .25mm Micron pen, draw a spiral in the center. Draw arrows between the first and second circles. Between the second and third circles, draw scallops.

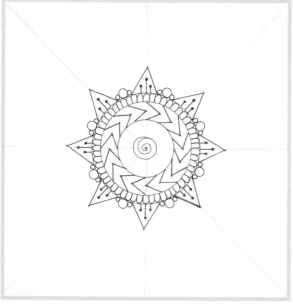

3 Draw 8 triangles around the third circle, leaving a small gap between them. Now draw small circles on either side of the triangles and one larger one between them. Draw flower pods (lines topped with dark dots) in the triangles as shown.

ADDING FACES AND HANDS

If you want the circles to look more like people, try adding faces and little lines to look like hands at the ends of the triangles.

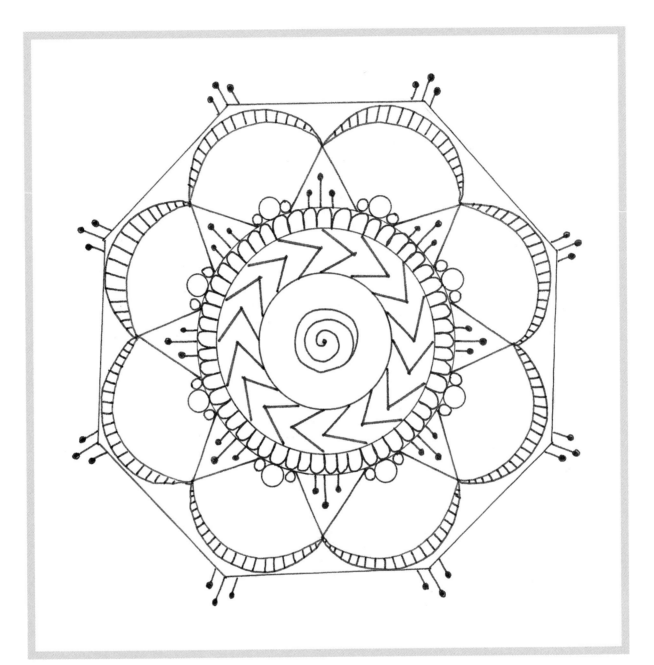

4 Draw a curved line from one triangle tip to the next all the way around the mandala (creating shutes), then repeat for another set of curved lines above (or below) the first. Now draw lines in between the curved lines (creating ladders). Draw straight lines around the shutes, making an octagon shape. Finish with flower pods at each angle. Erase all pencil lines.

Terra-Cotta

Moving further along with more patterns, we are now creating designs that are more complex. Choosing which pattern to use next can be a little overwhelming, but if you take it one step at a time, the outcome can be amazing.

When I was making this mandala, I knew what I wanted to create before starting, so I tried to pick patterns that would lend themselves to those that would be on a clay pot. The inspiration came from a picture I saw in a garden magazine that had these beautiful designs on a terra-cotta pot.

SUPPLIES

Bristol paper, 6½" (17cm) square

Compass

No. 2 pencil

Pigma Micron pens (black): .25mm (01) and .5mm (08)

Ruler

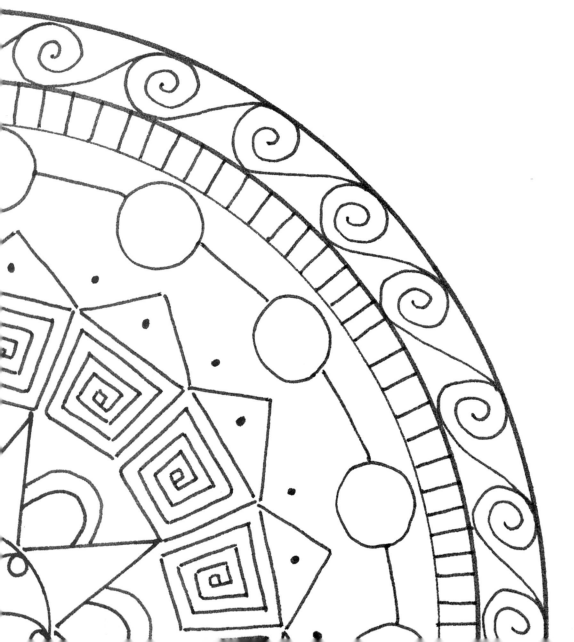

1 With a pencil lightly draw lines diagonally and across. With a compass draw a 1" (3cm) diameter circle. Go over the circle with the black .25mm pen.

2 Still using the pen, draw curved lines inside the circle, making a small loop at the end. Draw 8 triangles around the circle. Now draw double loops between the triangles.

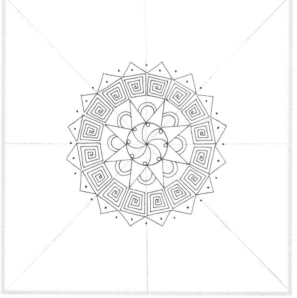

3 Draw square spirals around the triangles. Draw a triangle around each spiral square, and embellish with dots inside and out.

IDEAS ARE ALL AROUND

Inspiration can come from anywhere as with *Terra-Cotta* and *Cobblestones*. Look around you and see what inspires as you create your mandalas.

4 Draw circles connected by dashes around the dotted triangles. With the compass draw a circle around the circles and dashes. Go over this with the black .25mm pen. Again using the compass, draw another circle about ⅛" (3mm) away. Go over this line with the black .5mm pen. Now draw lines between these two circles. Draw swirls around the outside. Draw another circle going around the swirls, using the compass. Draw over the pencil line with the black .5mm pen. Erase all pencil lines.

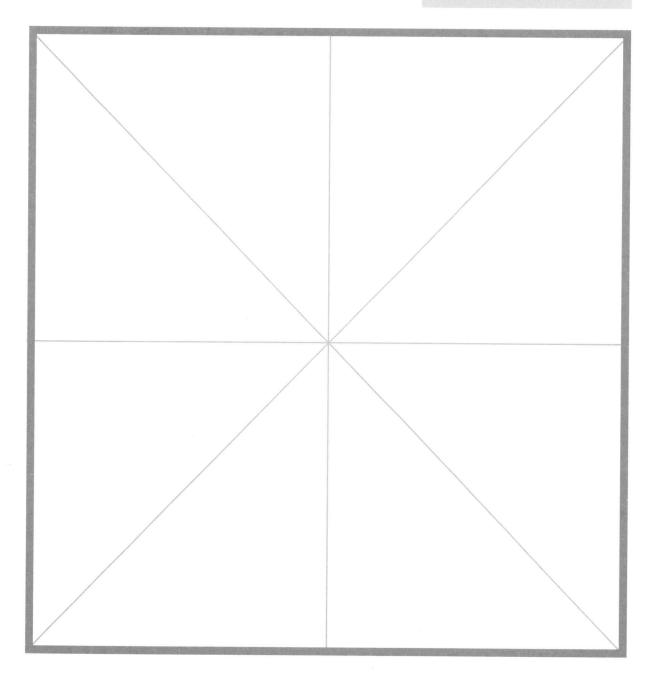

PROJECT
Test Pattern

Creating this mandala was just a matter of adding and removing lines until I got something I liked. Sometimes drawing in lines creates a space that gives me an idea for a particular pattern.

Watching television when I was growing up, a channel would display a test pattern on the screen to let you know the television station was done for the night. This mandala brings back memories of those times and how they have changed. The outside pattern line looks like an electrical charge dancing around my test pattern.

SUPPLIES

Bristol paper, 6½" (17cm) square

Compass

No. 2 pencil

Pigma Micron pens (black): .25mm (01) and .5mm (08)

Ruler

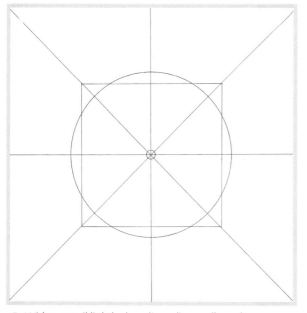

1 With a pencil lightly draw lines diagonally and across. Draw a small circle in the center. With a compass draw a 3½" (9cm) diameter circle. Using a ruler, draw a 3" (8cm) square in the center.

2 Go over the small center circle with the black .5mm pen. Still using the pen, start at one corner of the square and go over the line until it meets the circle, then go over the circle curve until it meets the next corner of the square. Continue going over the circle curves and square corners until all lines are drawn.

Draw a second line about ¼" (6mm) away from the line you just made. Add circles in between. Darken the lines with the black .5mm pen. Erase the center pencil lines. Draw diagonal lines from the points where the square corners and circle curves meet to the small center circle. There should be 8 diagonal lines.

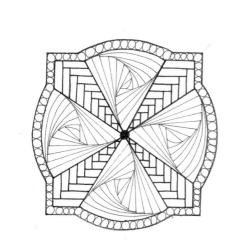

3 Darken the diagonal lines with the black .5mm pen. In the corners draw the Tangle pattern Betweed with the black .5mm pen. For the centers draw the Tangle pattern Paradox using the black .25mm pen. Fill in the small center circle.

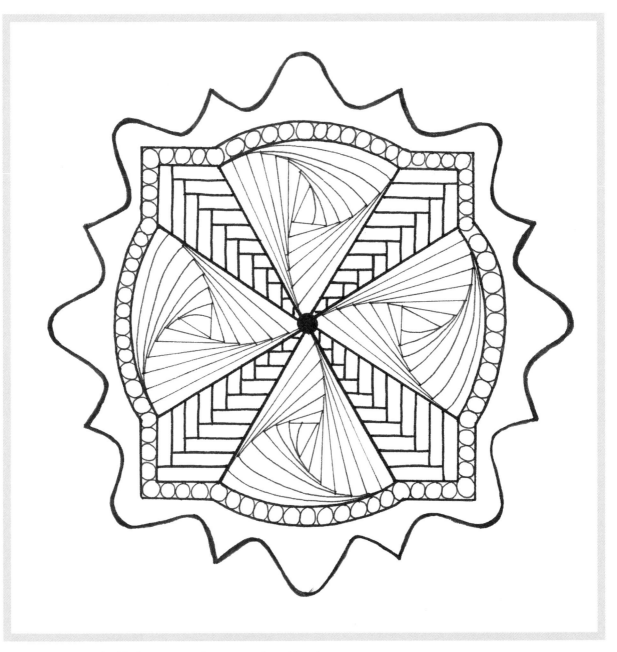

4 Using the black .5mm pen, draw a wavy line with points around the circle-square shape. Erase all pencil lines.

Butterfly Cocoon

We have been working on round mandalas so far, which is the basic form. Now we are going to draw a square mandala. When I looked at this one, it took the form of butterfly wings with cocoons in the center. It is sort of an art-deco design, which was accidental.

I do not always know what I am going to create, but when I draw one pattern at a time and take it slowly, the mandala starts to speak to me and take shape. You do not need to rush through your design. Take it slowly and see where it leads you—you might be surprised.

SUPPLIES

Bristol paper, 6½" (17cm) square

Compass

No. 2 pencil

Pigma Micron pen (black): .25mm (01)

Ruler

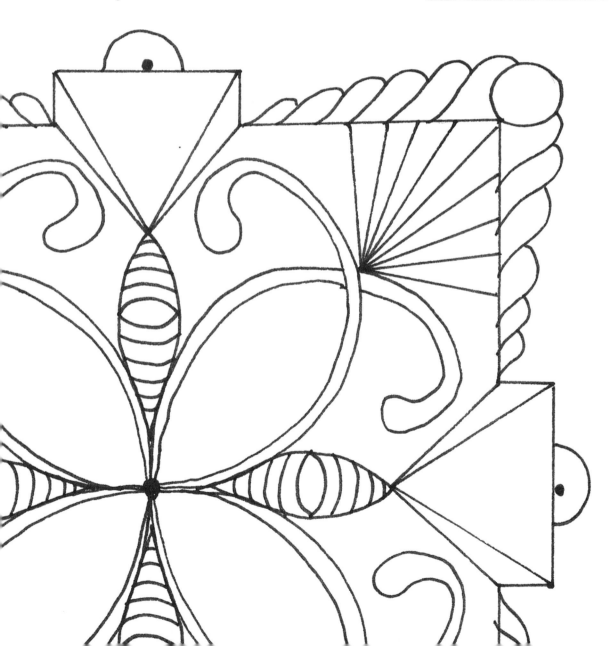

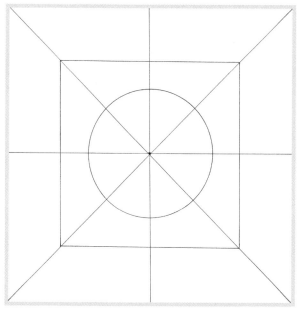

1 With a pencil lightly draw lines diagonally and across. Draw a small dot in the center. Using a compass draw a 2½" (6cm) diameter circle. Using a ruler draw a 3½" (9cm) square in the center and around the circle.

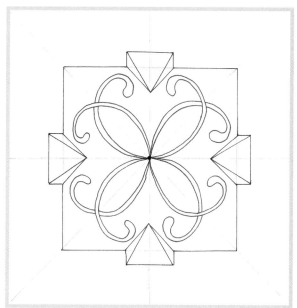

2 In the center of each side of the square, draw an inverted pyramid, using the black .25mm pen. Still using the pen, go over the pencil lines of the square, stopping at the pyramids. Draw a partial Mooka Tangle pattern in each quadrant of the square.

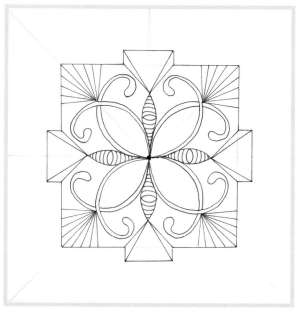

3 Draw cocoons from the point of each pyramid to the center. Draw lines from each corner of the square to the top center of the Mooka pattern, creating a fan.

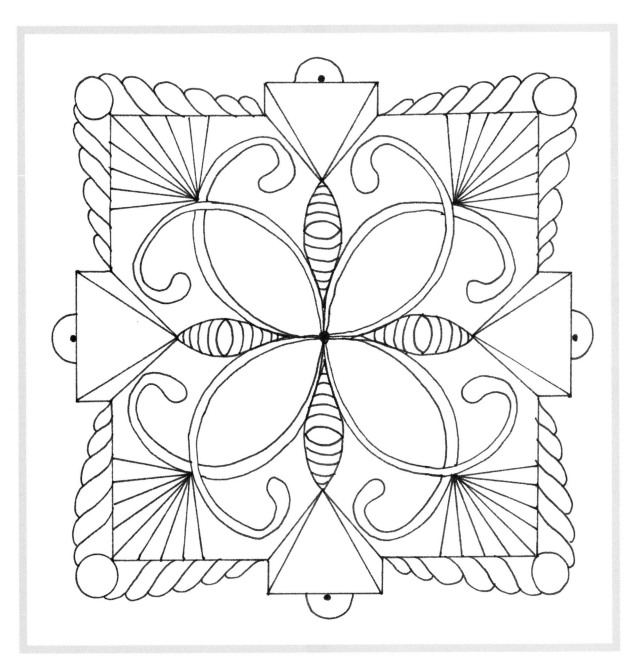

4 Draw a circle on each corner of the square and half circles
centered on the baseline of each pyramid. Add a small dot
in the middle of the half circles. Add curved lines going
from each pyramid to each corner circle, making taller
curves as you approach the circles. Erase all pencil lines.

Sign up for our FREE newsletter at CreateMixedMedia.com.

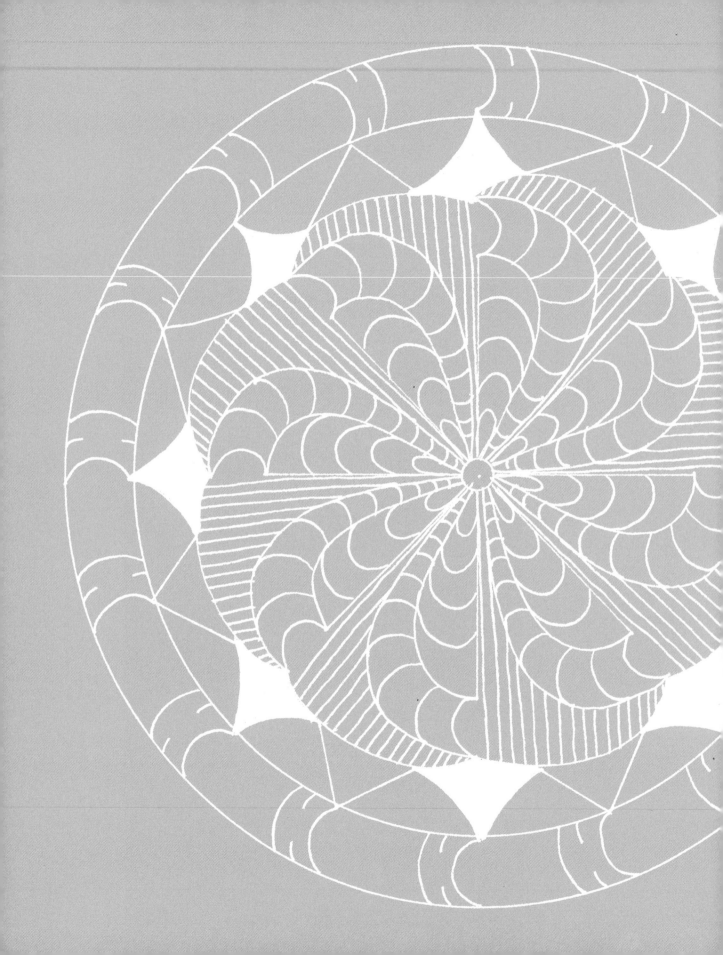

ADVANCED DESIGNS

There are a wide variety of mandalas in this chapter to expand your knowledge in drawing and creating designs. These mandalas are a bit more challenging and require a few more steps to complete. As with the mandalas in Chapter 3, each one starts in the center, whether it be with a dot, swirl or circle, and expands outward. We will use more patterning, and I will challenge you to come up with your own mandala. You will also learn to fill in or add weighted lines. These can enhance your designs.

So come and explore new ideas and possibilities for creating mandalas in this chapter.

Starburst

I had an idea of what I wanted to do before starting this mandala. I had some patterns in mind, and I knew I wanted to use colored paper. This mandala is drawn on silver scrapbook paper, but I did not like the shininess of it, so I drew on the back side instead.

Some of the patterns I had in mind for this mandala did not translate from my head to the tip of the pen. Instead of fighting the pattern, I let the design speak to me and changed my plan. After completing this mandala and looking at the swirl in the center and the dark triangles around the edge, I saw a star bursting outward.

SUPPLIES

Compass

Gray cardstock, 6½" (17cm) square

No. 2 pencil

Pigma Micron pens (black): .25mm (01) and .5mm (08)

Ruler

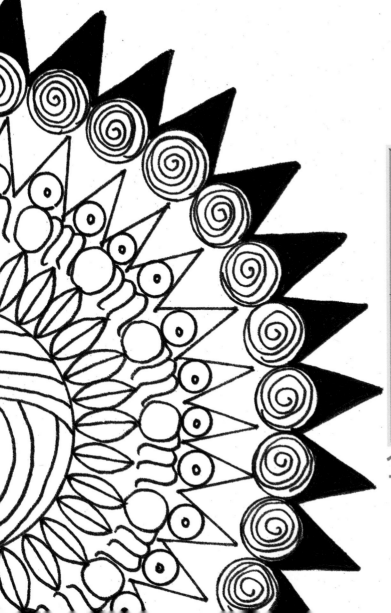

1 With a pencil lightly draw lines diagonally and across. Draw a small circle in the center. Using a compass draw concentric circles that are 1½" (4cm), 2¼" (6cm), 2½" (6.4cm), 3¾" (10cm) and 4½" (11cm) in diameter.

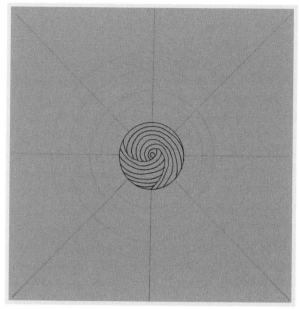

2 With the black .25mm pen draw a swirl pattern in the center circle.

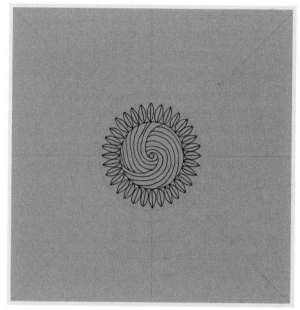

3 In the second ring, draw leaves. There should be 32 leaves around the second ring.

4 In the third ring draw circles at each of the diagonal and cross lines. Now draw a circle halfway in between each set of circles. Draw curved Ms between the circles. There should be 16 circles and 16 Ms.

5 In the next ring draw 32 triangles. Now draw circles inside the triangles, with a smaller circle in each center.

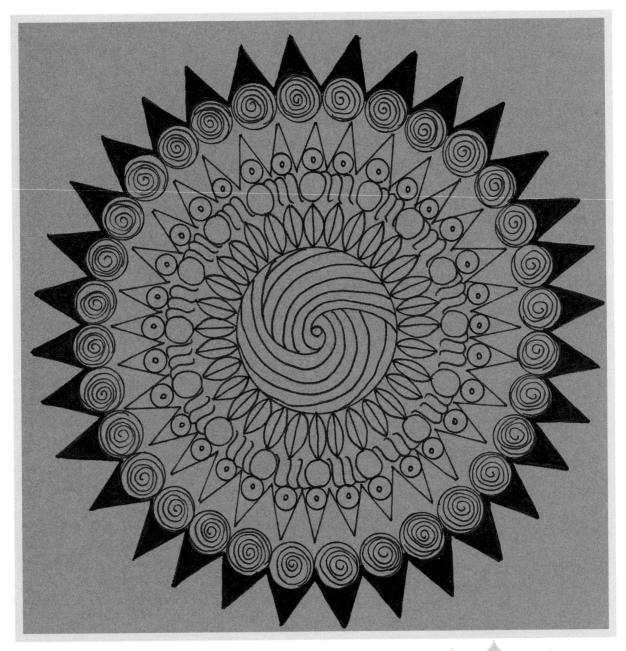

6 In the outer ring, draw 32 circles with swirls in the center. Draw triangles above each swirled circle and fill them in using the black .5mm pen. Erase all pencil lines.

SEE WHERE IT LEADS

If you have a pattern in mind that you want to use in your mandala but it is not working, instead of forcing the pattern, try something else, or let the pattern take you where it wants to go.

Sign up for our FREE newsletter at CreateMixedMedia.com.

Ferris Wheel

This *Ferris Wheel* mandala is a little more complex, and I think it will challenge you out of your comfort zone, which is a good thing. Before I drew this mandala, I knew I wanted to use the Tangle pattern Fengle. I was not sure how it would turn out, but when I finished, I quite liked the way it looked.

The tangle pattern was drawn twice, one behind the other. The circles drawn here and there remind me of the cogs that hold a Ferris wheel together. The spokes in the middle resemble the spokes on a Ferris wheel. The ends on the outside of the Fengle pattern look like they could hold passenger cars for riders.

SUPPLIES

Bristol paper, 6½" (17cm) square

No. 2 pencil

Pigma Micron pen (black): .25mm (01)

Compass

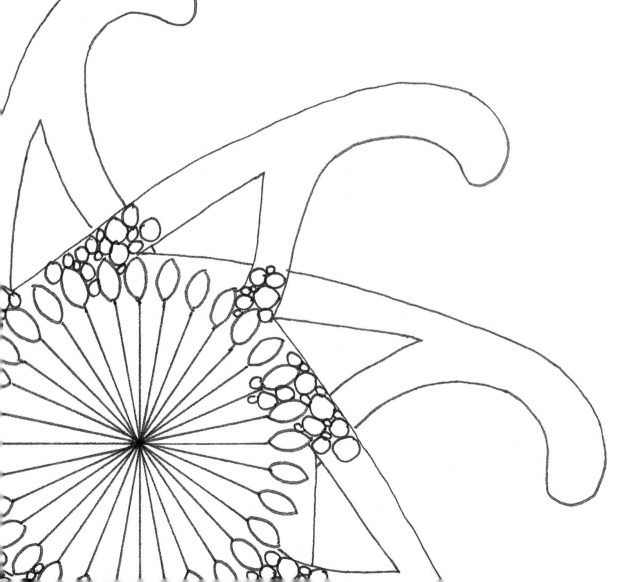

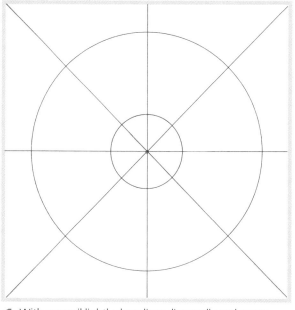

1 With a pencil lightly draw lines diagonally and across. Draw a small circle in the center. Using a compass draw concentric circles that are 1½ " (4cm) and 5 " (13cm) in diameter.

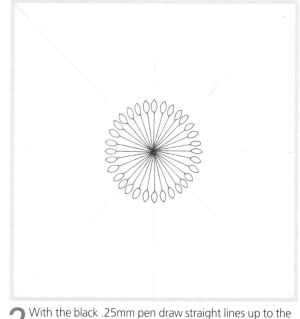

2 With the black .25mm pen draw straight lines up to the edge of the first circle. There should be 32 straight lines. Now draw a petal shape above each line.

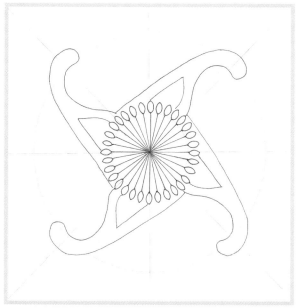

3 Add the Tangle pattern Fengle using the outer circle and diagonal lines as a guide.

TRY, THEN TRY AGAIN

You do not always have to know where you are going when you draw your mandala. If you do not like the way it looks, you can always try again.

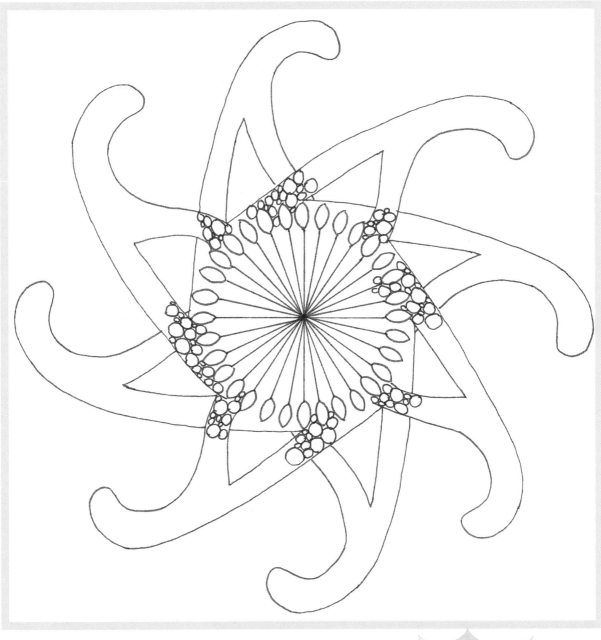

4 Draw another Fengle pattern behind the first one. One or both patterns can be filled in with other patterns, completely or partially. Erase all pencil lines.

CIRCLES EVERYWHERE

There was no rhyme or reason to the number or size of the circles I added. I just put them in until I was satisfied with the look. I could have filled one set with circles leaving the other one without.

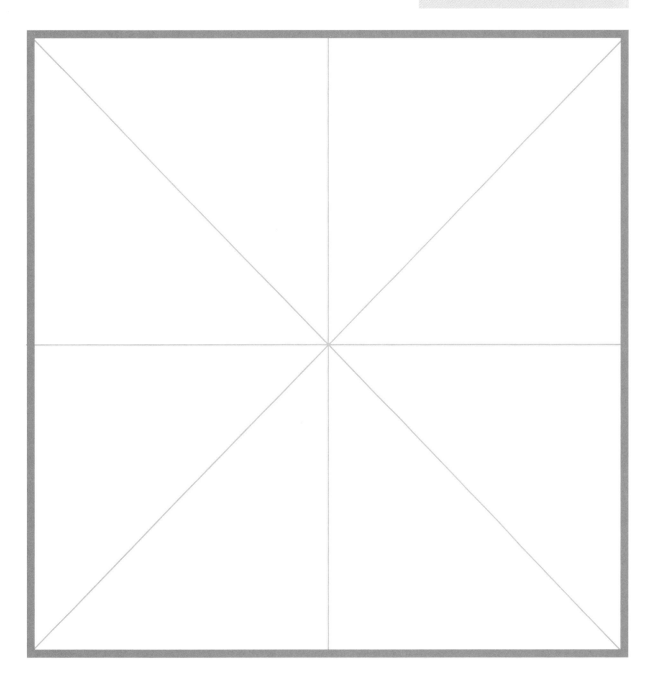

Dream Catcher

My go-to pattern is usually a petal or leaf shape, which I was going to do for the center of this mandala. I first draw one side going around the center and then the other side. However, when I was drawing the lines on the one side, I ended up liking the way that looked as opposed to the pattern I originally had in mind. After I finished drawing all my lines in, there was no distinction between them, so I added patterning inside.

I like to use double circles a lot in my mandalas and this one is no exception, but in this case I did not like how the center design just floated within the two outer circles. To remedy that, I drew triangles connecting the center design to the band created by the two outer circles. When my mandala was done, the connecting triangles and the curved lines on the band made it look like a dream catcher. I can actually see making a dream catcher using this pattern as my inspiration.

SUPPLIES

Bristol paper, 6½" (17cm) square

Compass

No. 2 pencil

Pigma Micron pens (black):
.25mm (01) and .5mm (08)

Ruler

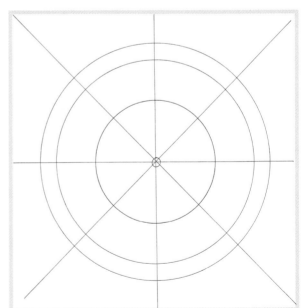

1 With a pencil lightly draw lines diagonally and across. Draw a small circle in the center. Using a compass, draw concentric circles that are 2½" (6cm), 4¼" (11cm) and 5" (13cm) in diameter.

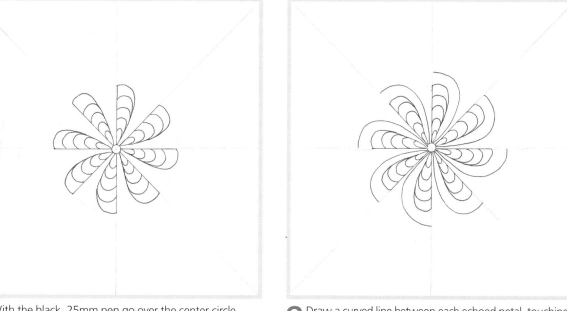

2 With the black .25mm pen go over the center circle, then draw straight lines to the edge of the 2½" (6cm) diameter circle, diagonally and across. There should be 8 straight lines. Draw 8 flower petals coming out from the center of the circle. Echo each petal.

3 Draw a curved line between each echoed petal, touching each of the straight lines. There should be 8 lines.

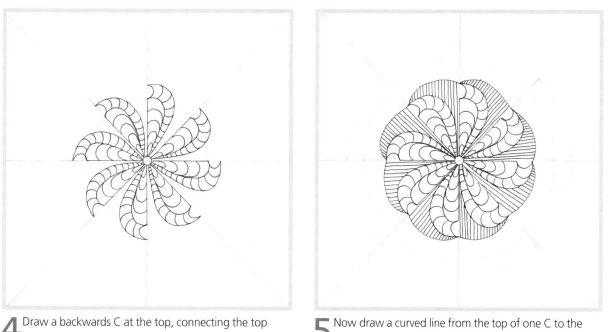

4 Draw a backwards C at the top, connecting the top of the petal and the line just drawn. Echo downward toward the center circle. Do this 7 more times.

5 Now draw a curved line from the top of one C to the top of the next C. Do this 7 more times. Fill in the shapes created with straight lines.

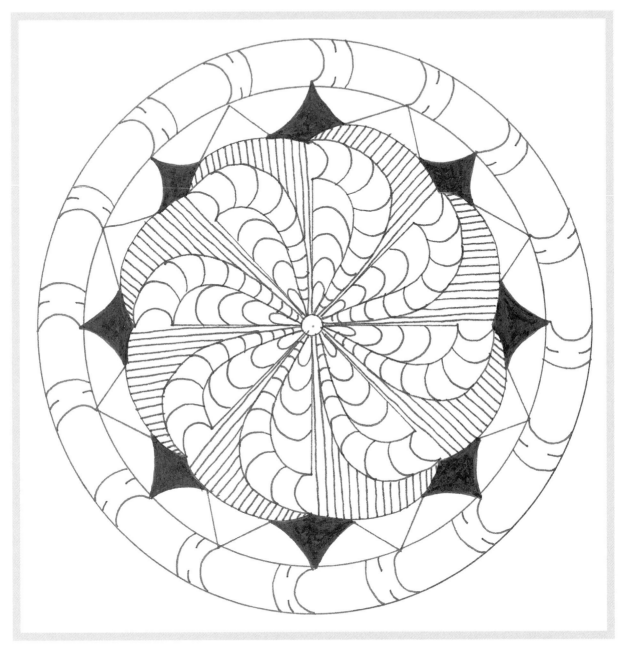

6 Add 16 triangles, making every other one slightly curved. Fill in every other one with the black .5mm pen. Draw a band using the last two rings as guides. Now add curved and broken lines to the band created by the two outer circles. Erase all pencil lines.

PROJECT
Holli

This mandala was a happy accident; it did not turn out anything like I had originally intended. Drawing the outer petals created petals in the center, which I liked, but when I started to draw the other lines, you could not distinguish one from the other. To solve that I filled in the center petals. I wanted to make the outer petals stand out, but I did not want to fill in the background. I felt doing so would make it too dark and too heavy, so I went with a checkerboard pattern, which brought balance to the mandala design.

When I finished the pattern, the mandala looked like a holly flower. I think it was the center petals like on a holly plant that made me see this.

SUPPLIES

Bristol paper, 6½" (17cm) square

Compass

No. 2 pencil

Pigma Micron pens (black): .25mm (01) and .5mm (08)

Ruler

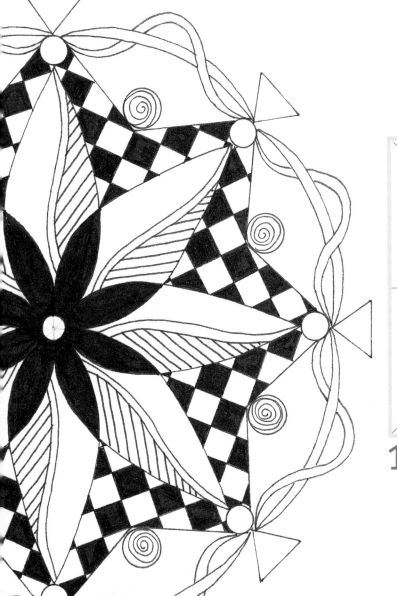

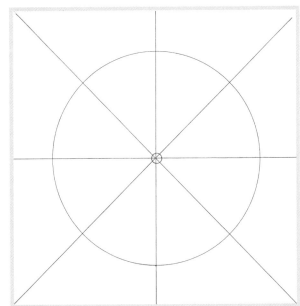

1 With a pencil lightly draw lines diagonally and across. Draw a small circle in the center. Using a compass, add a 4¼" (11cm) diameter circle.

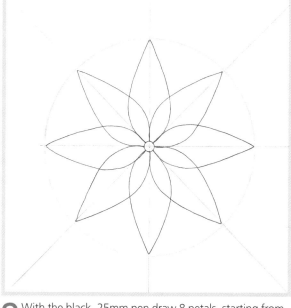

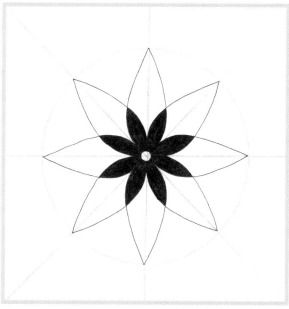

2 With the black .25mm pen draw 8 petals, starting from the center circle up to the outer circle. As each petal is formed, overlap the bottom, creating additional petals.

3 Fill in the smaller petals with the black .5mm pen.

4 For the outer petals, draw a double curved line, dividing the petals in half. Now draw diagonal lines on one half of each petal. Draw a circle on the tip of each petal.

5 Make a star on the outside of the developing shape using the circles as the points. Fill in the background with a checkerboard pattern. Draw swirl circles in each indentation of the star.

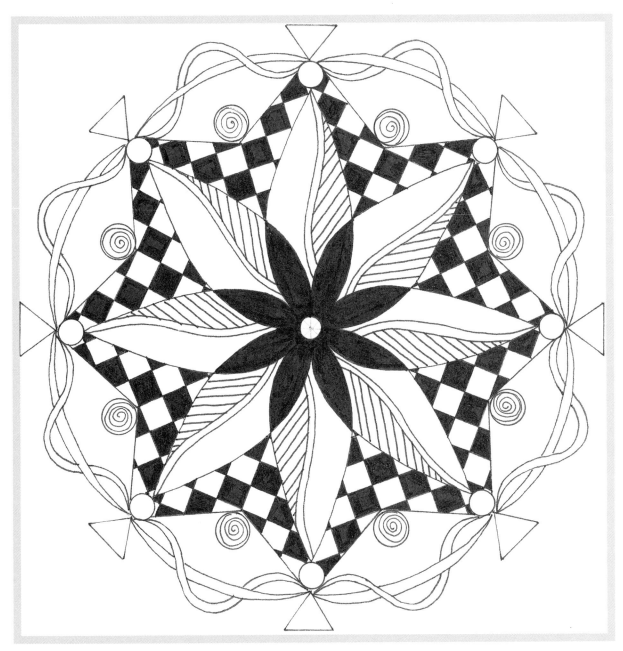

6 Draw a ribbon around your design, weaving in and out.
Draw inverted triangles at each point of the star. Erase all
pencil lines.

START SMALL

If something does not work when
you are drawing your mandala,
try adding a little of this or a little
of that to get your design moving
in a direction you like.

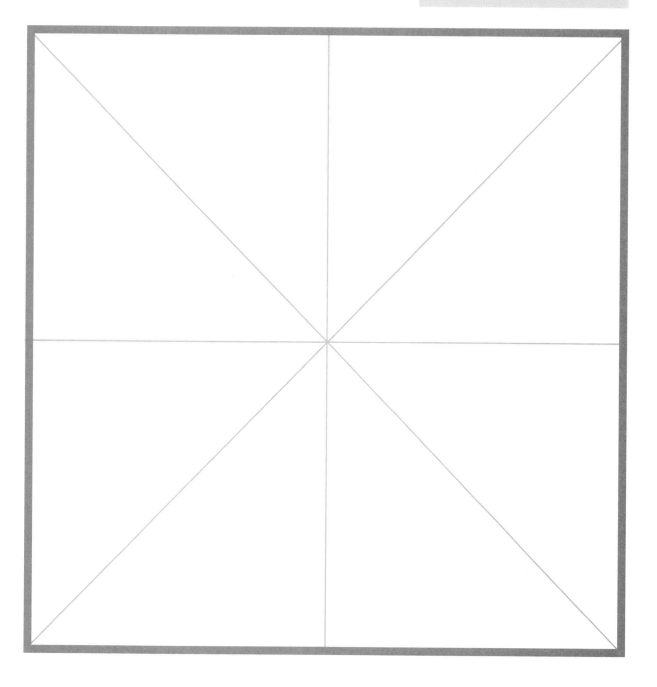

 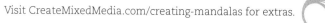

Kaleidoscope

Spoons, pineapples and hearts helped in the creation of this mandala. As usual, the mandala led me astray and I am glad it did because I like the way this mandala turned out. I like to finish my mandalas with a circle around them for the most part and then embellish the circle with a pattern or two. However, I felt that would not do for this particular mandala. I used petals instead, and I think that added to the patterns inside.

Because of the spoon patterns in the center—actually, I was trying to get the effect of a waterwheel—and the way the patterns connected with one another, the mandala took on the look of a kaleidoscope.

SUPPLIES

Bristol paper, 6½" (17cm) square

Compass

No. 2 pencil

Pigma Micron pen (black):
.25mm (01)

Ruler

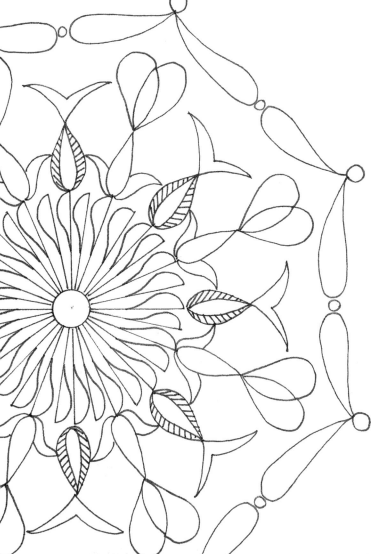

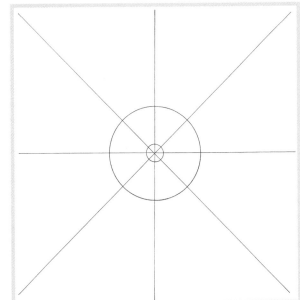

1 With a pencil lightly draw lines diagonally and across. Draw a small circle in the center. Using a compass, add a 2" (5cm) diameter circle.

2 With the black .25mm pen go over the center circle, then draw 32 straight lines going from the center circle to the outer circle.

3 Add a curve to turn each line into a spoon.

4 On the diagonal and cross lines, draw pineapple shapes. In between the pineapples, draw cornhusk shapes.

5 At the tip of each pineapple, draw an open V for its top. At the tip of each cornhusk, draw two fat teardrop shapes that form a heart, with overlapping lines showing (I call this an "open heart").

6 Draw a circle above each heart. Draw a thin teardrop on the side of each circle, starting at the base of each circle. Draw smaller circles in between the tips of the teardrops. Erase all pencil lines.

Sign up for our FREE newsletter at CreateMixedMedia.com.

Radio Frequency

I was in one of those "Let's go for it and see what happens" moods when I created this mandala. I played with patterns, adding some of this, a little of that, not worrying about what I was doing—just having fun. When I got tired of drawing straight lines, I threw in some crooked lines just because. After it was all said and done, the jagged lines and orbs looked like radio antennas.

SUPPLIES

Bristol paper, 6½" (17cm) square

Compass

No. 2 pencil

Pigma Micron pen (black): .25mm (01)

Ruler

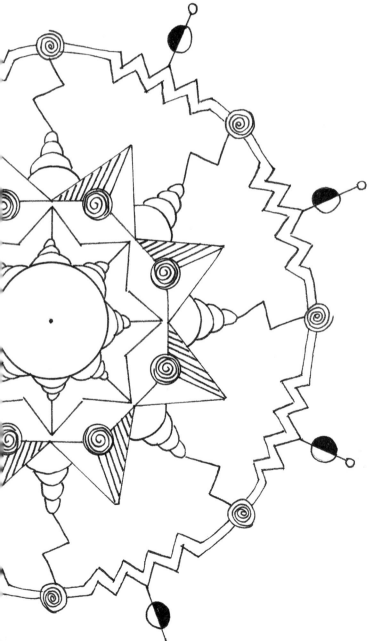

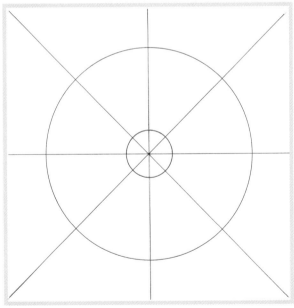

1 With a pencil lightly draw lines diagonally and across. Using a compass, add circles that are 1" (3cm) and 4½" (11cm) in diameter.

2 With the black .25mm pen, go over the 1" (3cm) diameter circle, then draw 3 stacked half circles (large to small) at each diagonal and cross line. From the center of each top half circle, draw about a ½" (13mm) line extending outward.

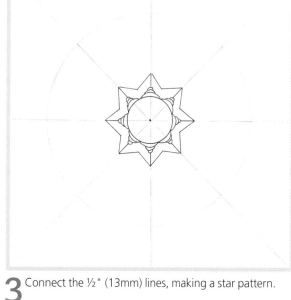

3 Connect the ½" (13mm) lines, making a star pattern.

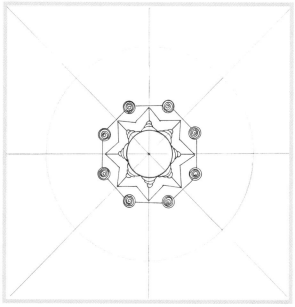

4 Halfway between each diagonal and cross line, draw swirl circles. Connect these circles with straight lines.

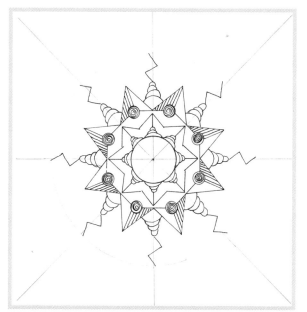

5 Draw triangles above each swirl circle. Now fill in half of each triangle with straight lines. Draw 4 stacked half circles in between each triangle. From the center of each top half circle, draw a lightning bolt extending to the 4½" (11cm) diameter circle.

Visit CreateMixedMedia.com/creating-mandalas for extras.

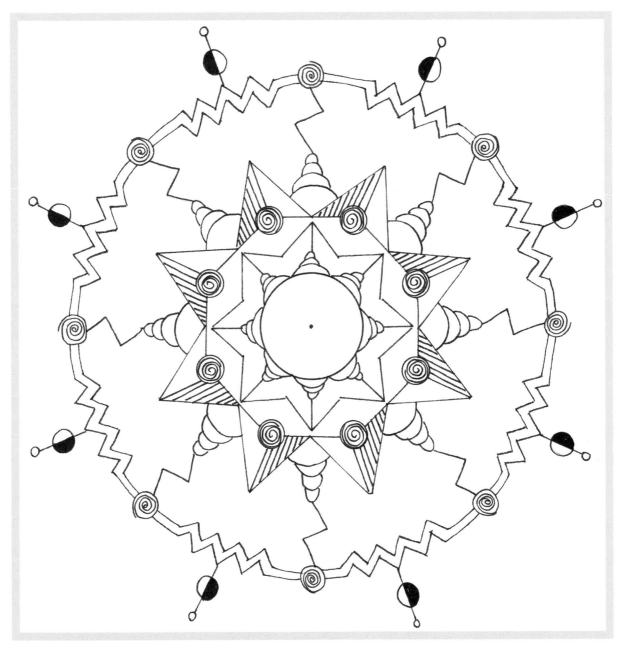

6 Now draw swirl circles at the end of each lightning bolt. Using the 4½" (11cm) diameter circle as a guide, draw a double jagged line connecting the swirl circles. Above each middle jag, draw about a ½" (13mm) line extending out with a half white/half black circle in the center. Finish the top with a smaller circle. Erase all pencil lines.

Cube Squared

I wanted to create a square mandala, having the
patterns going around it in a grid, so that is exactly
what I did. It got its name, *Cube Squared*, because to
me, that is what it looks like. What can I say about the
spikes on the outside? I just like them.

SUPPLIES

Bristol paper, 6½" (17cm) square

No. 2 pencil

Pigma Micron pen (black):
.25mm (01)

Ruler

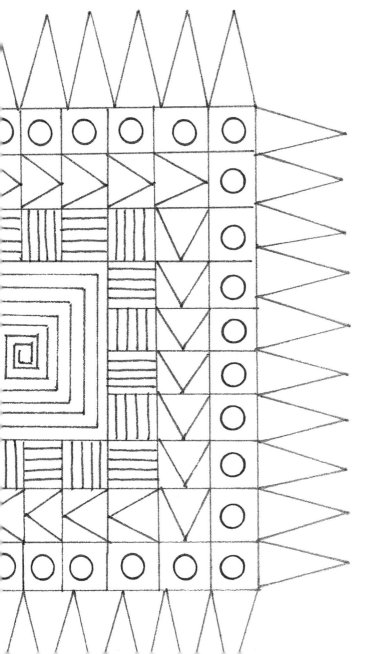

1 With a pencil lightly draw diagonal lines. With the black
.25mm pen and a ruler draw concentric 1" (3cm), 1½"
(4cm), 2¹⁄₁₆" (5cm) and 2¾" (7cm) squares.

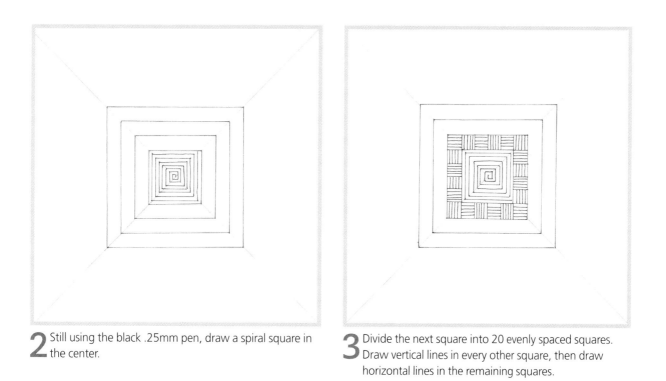

2 Still using the black .25mm pen, draw a spiral square in the center.

3 Divide the next square into 20 evenly spaced squares. Draw vertical lines in every other square, then draw horizontal lines in the remaining squares.

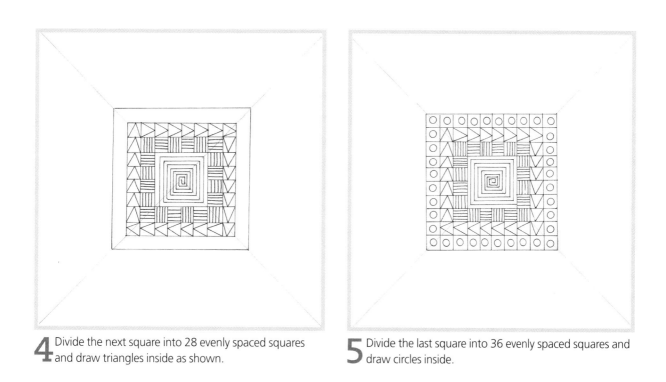

4 Divide the next square into 28 evenly spaced squares and draw triangles inside as shown.

5 Divide the last square into 36 evenly spaced squares and draw circles inside.

Visit CreateMixedMedia.com/creating-mandalas for extras.

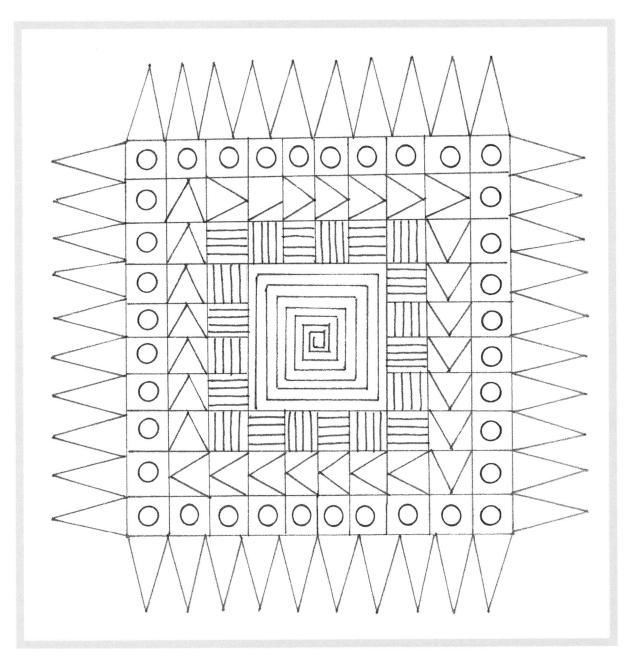

6 Now draw tall triangles around the outside of the square. There should be 40 triangles. (Optional: To give the center square the illusion that it is split, draw diagonal lines lightly using your no. 2 pencil.) Erase all pencil lines.

Sign up for our FREE newsletter at CreateMixedMedia.com.

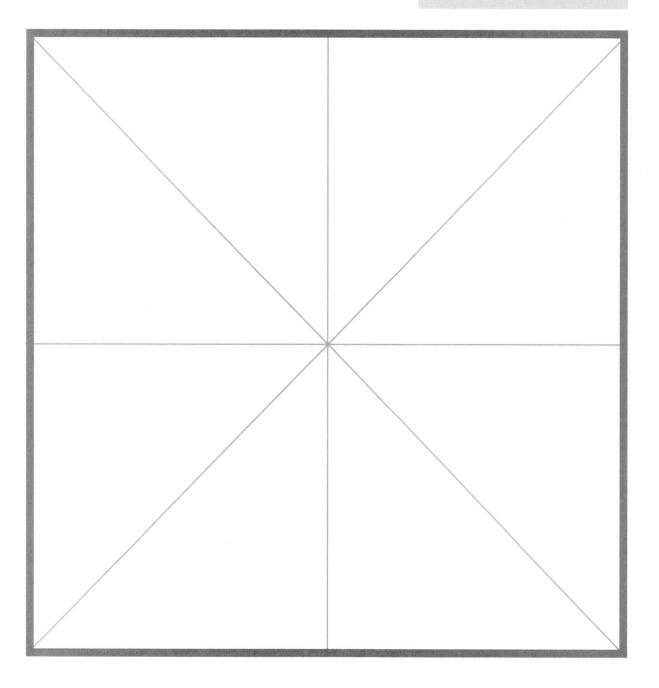

PROJECT
Sun Flower

This is another one of my favorite mandalas. As I've said previously, my go-to pattern is either leaves or petals, and that is what I started with here. I wanted these not to be the same-old, same-old, so I squared the tips a little and added more petals in the center. Instead of using a circle around the outside, this time I added a wavy line.

When I looked at this mandala after it was done, the black on the tips of the petals resembled sunflower seeds, and the wavy line made it look like huge petals around a flower center.

SUPPLIES

Bristol paper, 6½" (17cm) square

Compass

No. 2 pencil

Pigma Micron pen (black): .25mm (01) and .5mm (08)

Ruler

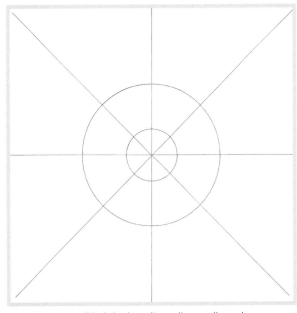

1 With a pencil lightly draw lines diagonally and across. Using a compass, add 1" (3cm) and 3" (8cm) diameter circles.

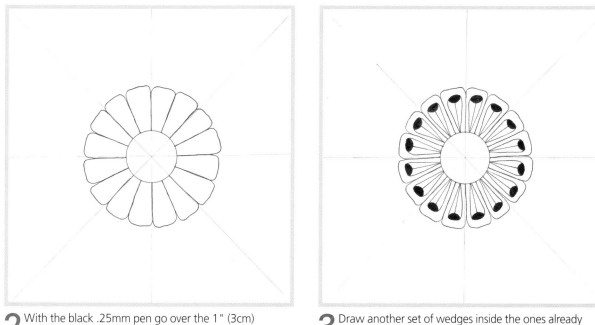

2 With the black .25mm pen go over the 1" (3cm) diameter circle. Now draw 16 wedges using the diagonal and cross lines and the 3" (8cm) diameter circle as a guide.

3 Draw another set of wedges inside the ones already drawn. Then draw a line down the center of the inside wedges and darken the tips with the black .5mm pen.

4 Draw circles around the perimeter of the wedges.

5 Draw small, medium and large rounded spikes around the circles. Draw a dark line inside each spike using the black .5mm pen.

Visit CreateMixedMedia.com/creating-mandalas for extras.

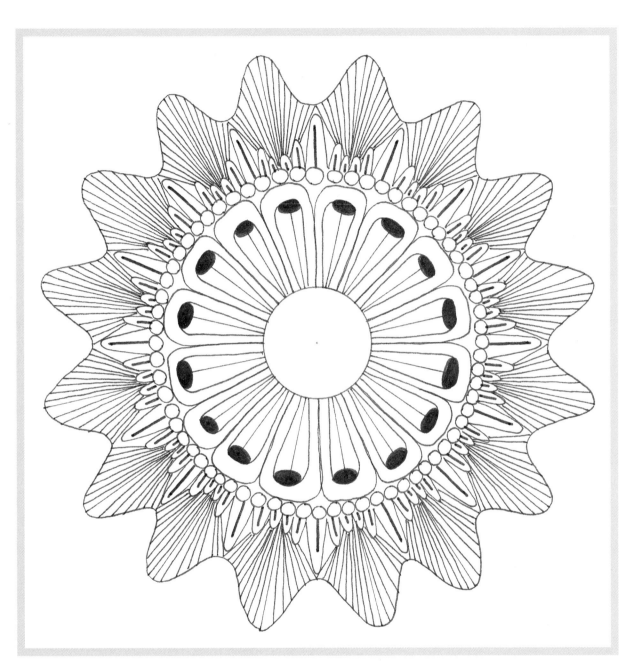

6 Draw a wavy line around the outside, coming inward on the large spikes and outward on the small spikes. Draw a line from the center of the peak of each wave down between the 2 small spikes. Draw additional lines on either side of the center line, fanning out on either side. Erase all pencil lines.

PROJECT
Bali Pods

This time I created a mandala with a square within a circle. Squiggle lines move outward from the center dot. Leaves extend outward to the corners. Instead of drawing the leaves, I used lines to form them. There are petals in between, embellishments around the square, and seedpods in between the outer circles that make up this mandala.

The veins of the leaves look like the movements of Balinese dancers, and with the seedpods all around, the name for this mandala became *Bali Pods*.

SUPPLIES

Bristol paper, 6 ½" (17cm) square

Compass

No. 2 pencil

Pigma Micron pens (black): .25mm (01) and .5mm (08)

Ruler

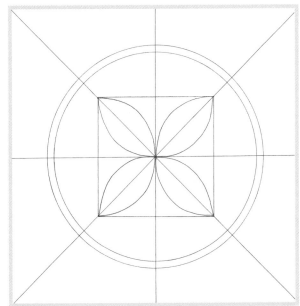

1 With a pencil lightly draw lines diagonally and across. Draw a 2" (5cm) square in the center. Using a compass draw a 4½" (11cm) diameter circle and a 4¾" (12cm) diameter circle around the square. Draw 4 leaf shapes diagonally in the center of the square, using the grid lines as guides.

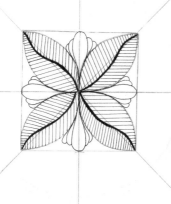

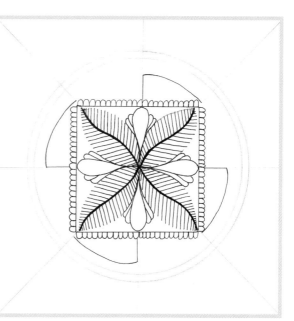

2 Using the black .5mm pen draw dark curved lines down the center of each leaf. Then, with the .25mm pen draw diagonal lines on each side of the center line. Still using the .25mm pen, draw petal shapes between each of the 4 leaves. Echo the petal shape on each side. Trace around the square with the pen.

3 Draw scallops around each side of the square. Draw a 1" (3cm) line in the center of each side of the square above the scallops. Draw a curved line from the top of the line to the corner of the square.

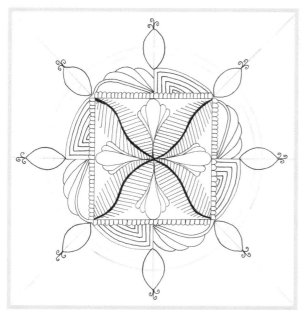

4 Echo your arch with additional lines. Draw fans starting from the outer corner of the square to the center. Draw one line on the inside of the first fan and then 3 more outside the first fan. Draw 8 leaf shapes on the corners and center points of the square. Draw curlicues on each.

5 Echo the leaves by drawing a line on the outside on either side. Draw another leaf in the center of each leaf.

6 Finish the mandala by adding circles on the outside of the center leaves. Go over the 4½" (11cm) diameter circle and the 4¾" (12cm) diameter circle with your pen. Erase all lines.

Sign up for our FREE newsletter at CreateMixedMedia.com.

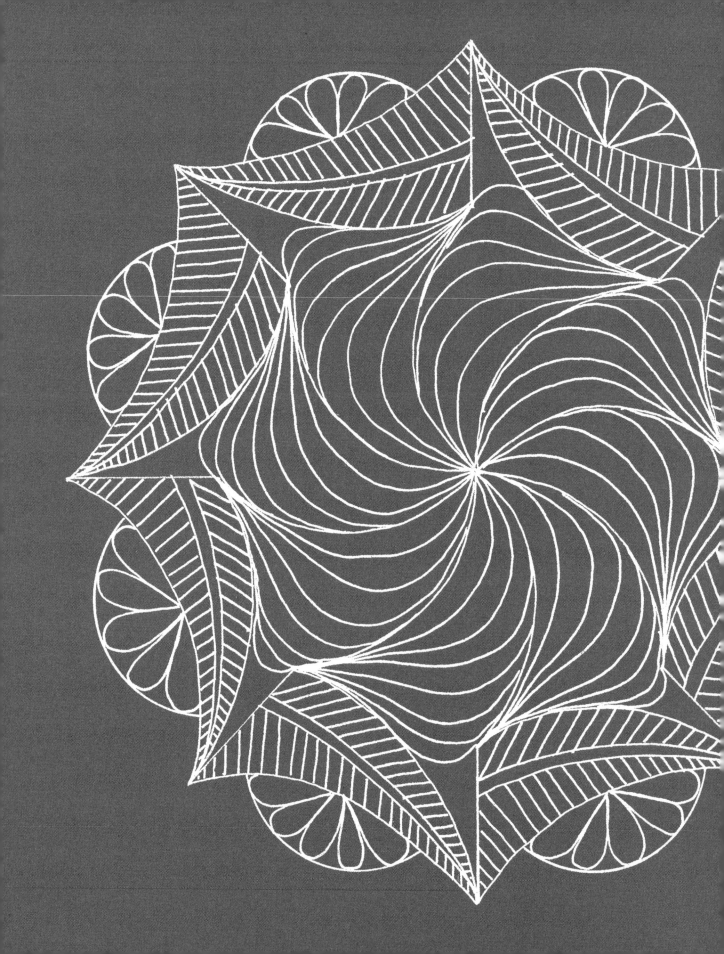

MANDALA TEMPLATES

As a beginner, learning how to draw a mandala can be a bit intimidating, and staring at a blank page does not help either. Using templates can help you get started. In this chapter, four different blank templates are shown with some finished examples to help you start. The templates are geometric, curvilinear or organic, or a combination of two or more of these styles. Note: You do not have to stay within the lines; they are just a suggestion. You can modify your mandala any way that is pleasing to you. Make several copies of the same template and try completing them with different patterns. Try modifying the shape of the template and see how you can make it your own.

Straight and Curvy Combo

This was the first template I created. I started with a circle in the middle and then added lines. I liked the way the curved and straight lines looked next to each other. Once I got my template done, I started drawing my patterns into the individual shapes.

SHAPES FIRST, THEN FILL IN

When drawing a mandala, try drawing the shapes first and then add your patterns.

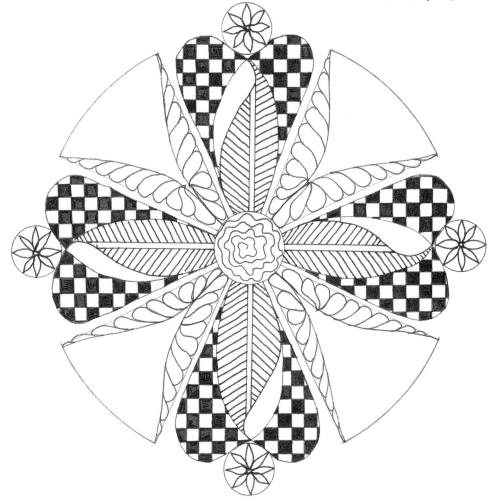

Finished Example

When I finished creating this template, it ended up looking like angels. I did not want to create a mandala with patterns in which the angel design would stand out. I must say, I had a hard time with this one because I did not want to modify the template or change it by going outside the lines. I wanted you to see how to use this template as is. However, taking a step back and starting with my go-to leaf pattern, the designs started to take shape within the template. I tried different patterns to fill in the triangles, but in the end, I liked the open look best.

Sign up for our FREE newsletter at CreateMixedMedia.com.

Star Power

This template started with a circle in the middle, and then I added star points using straight and curved lines. I like changing up the pattern sometimes to give the template a bit of interest. To enclose the design, I connected the star points with a curved line and added triangles in between.

LET THE TEMPLATE TELL YOU

As you are filling in the template with your patterns, let it speak to you. Look at it and see what starts to emerge.

Finished Example

I began drawing my pattern in the center. As I started adding the different patterns, the triangles began to look like umbrellas to me, so I went with that to complete my mandala.

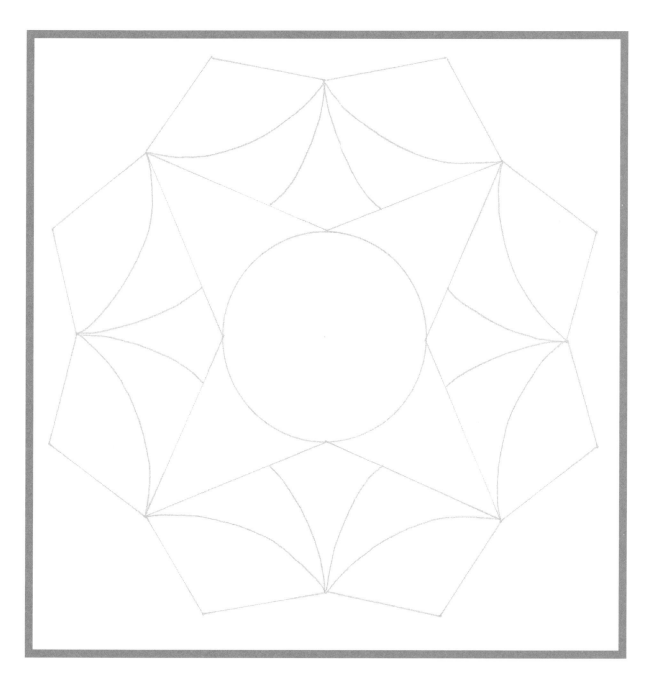

Tons of Turns

This template just spilled out of me. It was simple to create and simple to work with. Although I could not think what pattern to use in the center, I was still able to make it work. This template is very versatile. If you erase the center lines, you have a large space to fill in with a unique design or drawing. I can see adding eyes in all of the half circles and end up making this template a whimsical one.

FOLLOW THE LEADER

Drawing your patterns can be as simple as just following the design of the template and repeating it with lines.

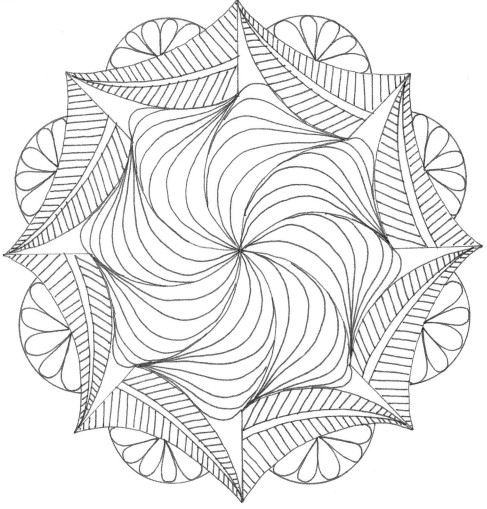

Finished Example

When I added my patterns, I started from the outside because I did not know what pattern I was going to draw for the inside portion of the template. When I got to the center, I still did not have a pattern in mind, so following the inside curves, I just drew curved lines.

Sign up for our FREE newsletter at CreateMixedMedia.com.

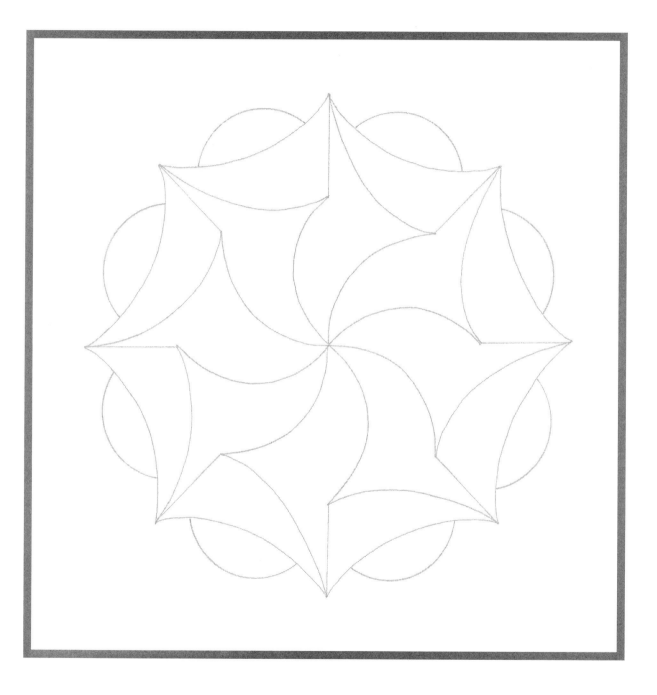

Crop Circle Swirl

My inspiration for this template was crop circles. I had just come back from a visit to Roswell, New Mexico, and while I was there, I saw a crop circle similar to this.

This is one of my favorite templates because of the simplicity. Using four different patterns and repeating them around the mandala, making sure there was a balance between the light and dark patterns, brought out this mandala's true potential. This template is very versatile. You can create a different pattern in each section or the same pattern and modify as you move onto the next section. I would use this template as a whole, meaning I would not delete any lines as I worked my patterns in. I wanted something fun in the center but did not want it to take away from the main design, so I just added a little something for interest and there you have it. Of course, you could make your center pattern more elaborate or leave it blank and add a touch of color in the center.

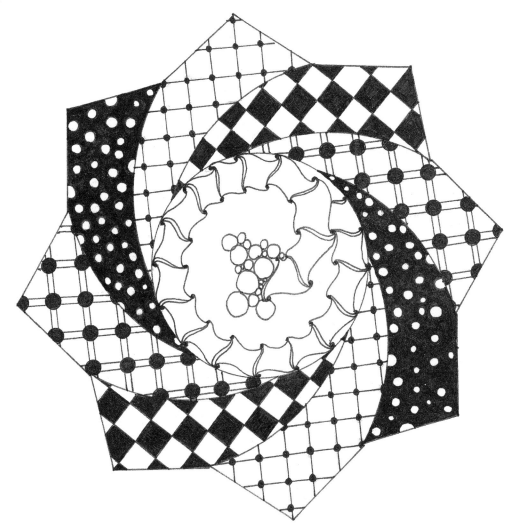

Repeat and Vary
Drawing patterns can be as simple as repeating a pattern. You can also use the same pattern and vary it a bit. Instead of using white dots by coloring in the background, I could just as easily have drawn in black dots.

Sign up for our FREE newsletter at CreateMixedMedia.com.

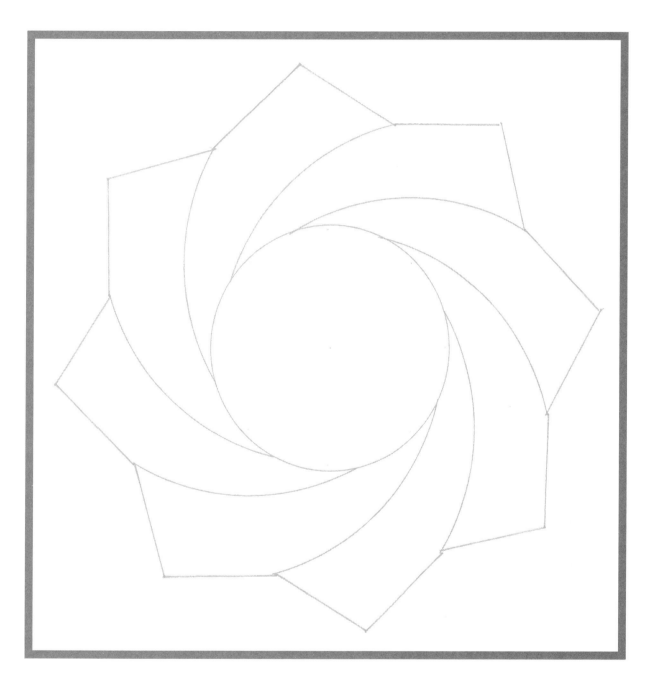

 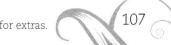

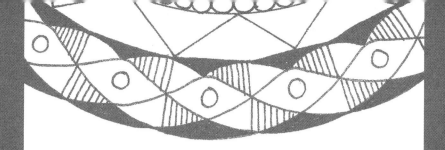

GETTING CREATIVE

This chapter will take what you have learned about creating mandalas a step further. Sometimes after repeatedly creating the same thing, we get to that "now what?" phase. We ask ourselves, "What else can I do with this? How can I take this to the next level?" The following projects will show you how you can create mandalas in unconventional ways by using different methods and tools. So let's have some fun and see what we can come up with to take our mandalas beyond the "now what?" phase.

Snowflakes

Remember as children, during the holidays, we made snowflakes? Remember how they were hung from the ceiling, bringing the outdoor holiday season inside? Well, we are going to take down one of those snowflakes and use it as our pattern to create a one-of-a-kind mandala. After all, no two snowflakes are the same.

SUPPLIES

Bone folder

Bristol paper, 6½" (17cm) square

No. 2 pencil

Pigma Micron pens (black): .25mm (01) and .5mm (08)

Scissors

Tracing paper

Optional: cardstock, craft knife, low-tack tape

Snowflake Design
This is the snowflake I started with.

SELECTIVELY SLICE

Keep in mind when cutting out your snowflake not to cut all the way through to the other side; otherwise, your snowflake will fall apart. You can also draw in a design first before cutting into the paper. If you want to make your snowflake sturdier, glue it to cardstock and then cut around the shapes using scissors or a craft knife.

Finished Example
After I drew my snowflake pattern, I had no idea what I was going to draw next. As I continued to look at the pattern on the mandala, shapes started to emerge. I drew a line down the middle of the heart shapes and when I added a heavy line around the shape, bugs started to form. I rounded the triangles to make leaves. I added lines and shapes and, without realizing it, bees and butterflies flew onto my mandala.

1 Cut a 6" (15cm) square piece of tracing paper. Fold it in half diagonally to form a triangle. Throughout these next steps, keep the fold on the bottom. Mark the center of the triangle on the fold, lightly with a pencil. Draw a line, lightly with a pencil, from the bottom center point to the center top of the triangle on both sides to form a V. Take the right side bottom point of the triangle and fold it up to the left pencil line. Now take the left side bottom point of the triangle and fold it up to the right pencil line or edge of the fold on the right side. Your triangle is now folded into thirds. Fold in half again.

2 With scissors start to cut out various shapes from each side of the tracing paper (circles, squares, etc.). Cut off the top part of the triangle (opposite from the point).

3 Open up the snowflake and center it on the bristol paper. With a pencil lightly draw around the cutouts and outer edge of the snowflake. Note: To help keep the snowflake from moving around, tape it down with low-tack tape.

4 Start to draw your shapes using the black .25mm pen. You can use the shapes as is to create the mandala, or lines can be connected and/or taken away, creating different shapes. Use the black .5mm pen to color in and darken some of the shapes and lines.

5 Erase all pencil lines.

Stencils

Stencils are a good tool to have for creating mandalas. Stencils help create not only the shape for you but also some of the patterns. Here I have two different examples created from one stencil. You can see a dramatic difference between the two just by choosing which lines to use or not use. On one I used a heavy line, and on the other I went for a more delicate look. The choice is yours.

SUPPLIES

Bristol paper, 6½" (17cm) square

No. 2 pencil

Pigma Micron pens (black): .25mm (01) and .5mm (08)

Stencil, smaller than 6½" (17cm) square

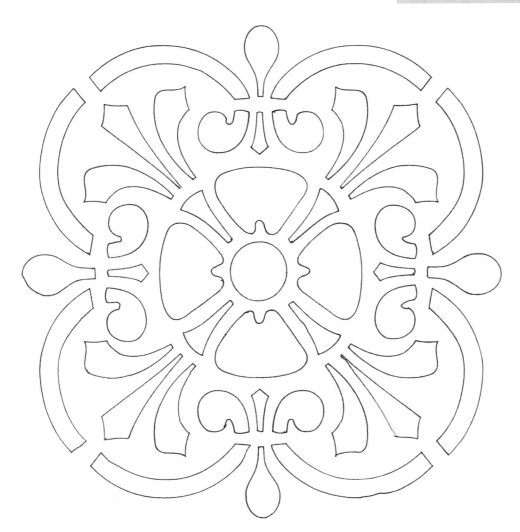

Stencil Design
This is the stencil I started with (Plaid Folk Art Painting Stencil #30606).

Sign up for our FREE newsletter at CreateMixedMedia.com.

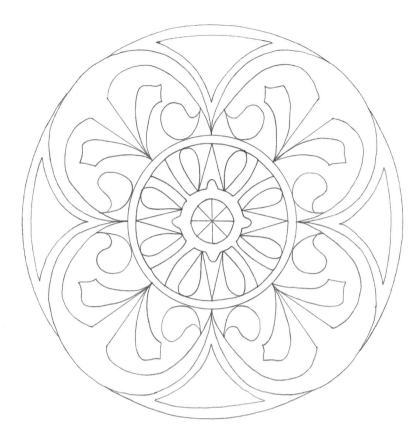

First Finished Example
With this first example I wanted to keep most of the stencil lines and shapes in my mandala so you could see how stencils can be used. If you look closely, you can see most of the shapes and lines of the stencil. I eliminated very few of the lines and enhanced others. Keeping true to the stencil design made for a very simple and easy mandala.

1 Be sure to choose a stencil that will fit on the piece of bristol paper. Center the stencil on the paper.

2 With a pencil lightly trace around the stencil.

3 Decide what lines you want to use from the lines drawn, either connecting or removing them. With the .25mm pen draw over the pencil lines. Keep going over the lines, adding more lines, curves, circles and shapes until you get the look you want. Use the .5mm pen to fill in shapes and darken lines if desired.

4 Erase all pencil lines.

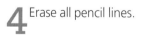

TAKE THE SAME STENCIL IN DIFFERENT DIRECTIONS

You can use the same stencil repeatedly. By choosing which lines to connect or remove, you will get a different look every time. You can also use the stencil as is and add patterns to the individual sections.

Visit CreateMixedMedia.com/creating-mandalas for extras.

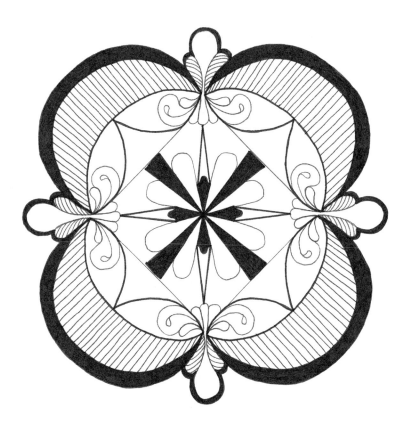

Second Finished Example

This example is created using the same stencil but has a very different look. I removed a lot of the stencil lines and shapes to create my own design. I wanted to see how different I could make this mandala look from the stencil. I still kept some of the bones of the stencil but made it more my own.

HOW TO CREATE YOUR OWN STENCILS

Supplies: Paper, stencil template, pencil, permanent marker, craft knife
Optional: Stencil cutter

1. Cut out a square from a piece of paper, and draw your design in pencil. The simpler the design, the easier it will be to cut out. Keep in mind that some of the lines need to stay connected; otherwise, the stencil will fall apart.

2. Cut out a square from the stencil template to fit your design. Place the stencil template over your design and trace, using a permanent marker.

3. Cut out your design from the stencil template using either a craft knife or a stencil cutter.

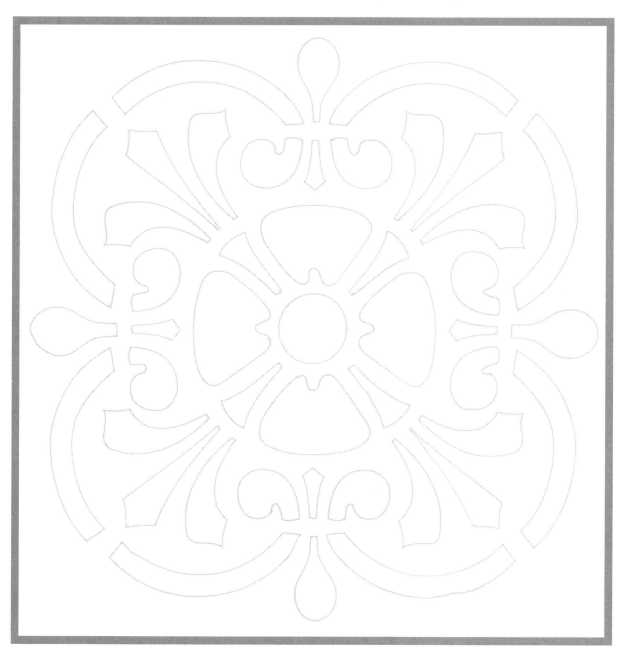

Practice Stencil
Now try making your own mandala
design from the same stencil I used.

Spirograph

The origins of the Spirograph as a drawing toy go back to 1908, when a similar device called the Wondergraph, which used a system of gears to produce geometric drawings, was marketed by the Sears and Roebuck Co. The first Spirograph toy was marketed by Kenner in the United States in 1965, and today, currently a Hasbro toy, it is a natural tool to use when making mandalas. There is no need to worry about making the perfect circle for your mandala when using a Spirograph; it takes the guessing out of the equation for you. The Spirograph has a number of circles, squares and triangles in all different sizes; you could not possibly run out of ideas for creating your mandalas.

SUPPLIES

Bristol paper, 6½" (17cm) square

No. 2 pencil

Pigma Micron pens (black): .25mm (01) and .5mm (08)

Spirograph

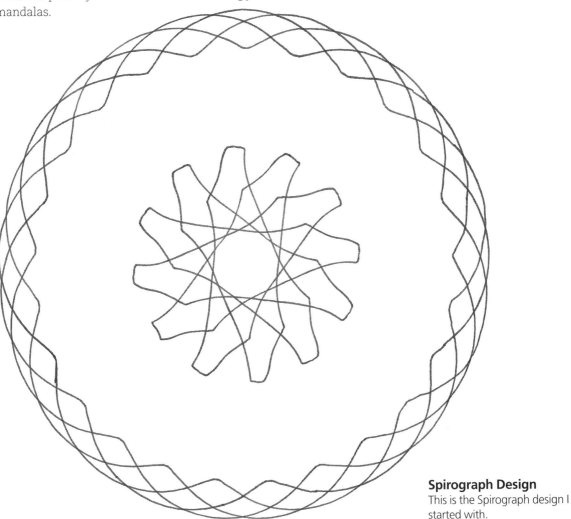

Spirograph Design
This is the Spirograph design I started with.

Sign up for our FREE newsletter at CreateMixedMedia.com.

I could have stopped at the initial design when I drew my mandala, but I added more lines and patterns and filling in here and there, and you can see a great difference between the two.

1 For the inner pattern I chose wheel #144/96 and used hole 6. Center on the bristol paper and begin to draw the pattern using the .25mm pen.

2 For the outer pattern I chose wheel #150/105 and used the smallest circle, and with wheel #24 I used hole 1. Center around the inner pattern and begin to draw the outer pattern with your .25mm pen.

3 Once both initial patterns are drawn, start to add other patterns, lines, curves, circles and other shapes to develop the mandala. Also try joining some of the lines together. Use the .5mm pen to fill in shapes and darken lines if desired.

MAKE A HOMEMADE SPIROGRAPH

You can create your own Spirograph using cogs and wheels from the hardware store. Old clock parts can also be used.

INSPIRED IDEA
Half and Half

I love the look of black ink against white paper, but I love how a white pen against black paper looks even more dramatic. Here I combined the two into one. You can buy two-toned colored paper, but I have never seen black-and-white paper. To solve the problem I cut a piece of paper in half from the white and from the black and taped the two together. The only problem I had when drawing my mandala was remembering to switch pens. Sometimes I was so into creating my mandala that I forgot.

SUPPLIES

No. 2 pencil

Paper cutter or scissors

Paper tape

Pigma Micron pen (black): .25mm (01)

Ruler

Sakura Gelly Roll pen (white)

White chalk pencil

White and black cardstock

Simple Start
This is the simple half white/half black design I started with.

118

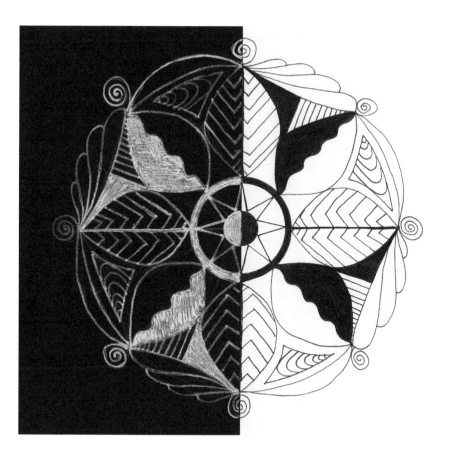

Finished Example

I had already drawn this mandala a while back using a black pen on white paper. I thought this was the perfect time to see what it would look like half black/half white. I chose this particular mandala to draw because of its simplicity. You can see the design clearly, so it is easy to replicate. It is a great beginner design to start with because you get a taste of what this type of mandala is like to draw without too much difficulty.

1 Cut a 6½" (17cm) square from both the white and the black cardstock. Cut both squares in half, then tape a black half and a white half together. Make sure that both halves butt up against each other as closely as possible.

2 Draw lines diagonally and across using the no. 2 pencil on the white side and the white chalk pencil on the black side.

3 Draw the mandala using the black .25mm pen on the white side and the white Gelly Roll pen on the black side.

4 Start with a circle in the center, followed by a star around it. Draw another double circle, filling it in with black on the white side and white on the black side.

5 Continue drawing the design with leaves, swirls and lines.

6 Erase all pencil lines.

DON'T SPLIT UP

When drawing your mandala, draw it as a whole and not one side first and then the other. For example, do not draw totally on the black side and try to duplicate the pattern on the white side. You will not get that even flow and your mandala may end up looking disjointed.

Illuminated Letters

The word *illuminate* means "to fill with light." During the Middle Ages, ancient literature was transcribed by monks to highly decorated texts called "illuminated manuscripts." The illuminated letter, typically the first letter of a page or paragraph, is enlarged and decorated with gold.

An illuminated letter mandala is like any other mandala, except there is a letter in the center. Instead of starting with a circle in the center, you are starting with your letter. Your letter can be as elaborate or as plain as you like. There are many types of fonts online, so there is no need to worry about not liking your handwriting. Try drawing your pattern through your letter. It will give you a totally different effect. Experiment and see what you like best.

SUPPLIES

Bristol paper, 6½" (17cm) square

Compass

Gold leaf

Gold metallic gel pen

Letter of your choice (hand drawn or photocopied)

No. 2 pencil

Pigma Micron pen (black): .25mm (01)

Scissors

4" (10cm) square double-sided mounting adhesive

Illuminated Letter Design

Before starting my design, I traced part of my letter in the center of the drawn circle. The partially traced letter is my registration mark. Registration marks not only give you a guide to help place your letter onto your mandala, but they also give you a guide for where to start and end your pattern(s). Once I got the placement of my letter, I was able to determine where to start drawing.

Finished Design

I looked at some old illuminated letters online to see how they were decorated. I wanted to keep that same feel in my mandala, so I chose a scroll. I drew the pattern, keeping the design the same and balanced around my letter. In keeping with the inside pattern, I added a similar scroll pattern on the outside of the circle to finish the design.

1 In pencil, draw or trace the letter you have chosen on the double-sided mounting adhesive. Cut the letter out. Save the other piece for another project.

2 On the bristol paper, draw a 5" (13cm) diameter circle in the center with the black .25mm pen. Center the letter in the circle and draw registration marks for placing the letter. Then remove the letter and draw your design. Note: Your design can be drawn either before or after you place your letter in the circle.

3 Peel away the paper from the back side of the letter and place it in the center of the circle, matching up the registration marks. If the design was not drawn beforehand, finish drawing it now.

4 When you are finished with your design, peel away the top layer of the paper from your letter and apply the gold leaf following the manufacturer's instructions.

5 Outline the letter with the gold metallic gel pen.

6 Optional: Add another design around the outside of your mandala circle.

GIVE COLOR A TRY

In creating this mandala, I used gold leafing, but you can use color instead.

CHAPTER 7

GALLERY

I love going to art galleries and looking at all the different artworks on display. I like to see what new techniques, styles and ideas are out there. Creative and talented artists always fascinate me. I love a book or magazine that has a gallery section. It shows how individual artists have taken an idea and used it in multiple and unique ways. I am amazed how artists can come up with so many creative ideas. The possibilities seem endless.

To that end, I must say I am amazed that I created all of these different mandalas myself. As you look through this chapter, view it as if you were in an art gallery, gazing upon all the different artworks. Do not just glance at each one, but be inspired to either try one or all of these mandalas or come up with your own unique art piece. Try to take something from each one.

Creating these mandalas not only challenged me to think outside the box, but also pushed me to make each mandala uniquely different. Sometimes you do not know what you can do until you go through the challenge. I hope you will challenge yourself to do the same, but most importantly, I hope you have fun in the process.

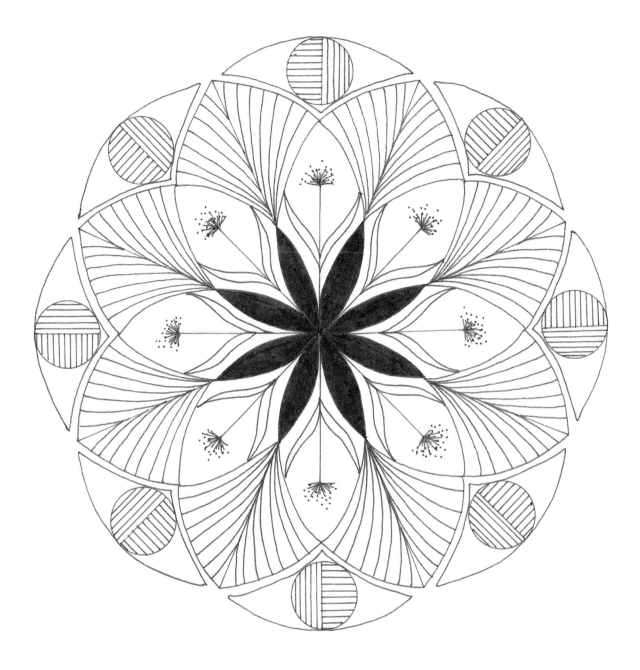

Lotus Bloom

Although this mandala has many lines throughout, I think it has a delicate look. Usually, if there is a strong center as in this one, I will make the outside strong as well for balance. I did not feel *Lotus Bloom* needed this. If I had, I think it would have taken away from the delicate look of the design. Looking at Asian designs in the past, this design reminded me of the lotus flower in bloom.

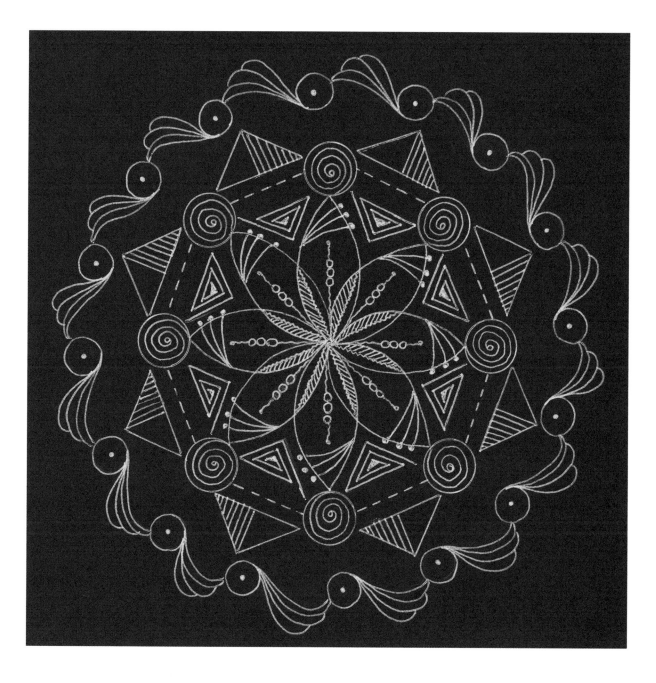

A Stitch in Time

As with the mandala *Holli* in Chapter 4, the center design made double petals when drawing the larger petal. This time I used lines to fill in half of the inside petals. It gives the design a light and open feel. The white lines against the black background really enhance the design of this mandala. The dash marks around the design remind me of hand stitching, and since it took me some time to draw this … well, you know where I am going with this in naming the mandala *A Stitch in Time*.

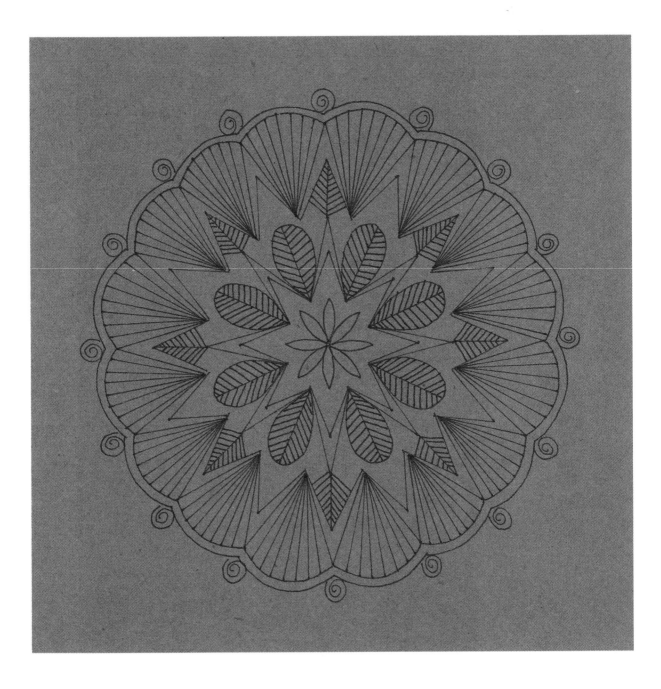

Arrowheads

I used black pen on tan cardstock for this mandala. Notice that this mandala uses mostly straight lines for the design. As you see, you can get a dramatic effect using only lines. I saw arrowheads: round, pointed and fanned.

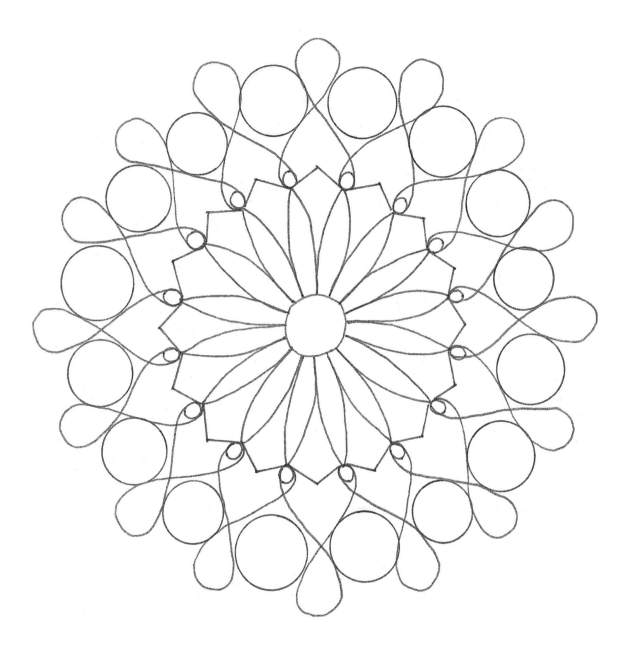

There

I was trying different loops and circles when drawing this mandala. I like the simplicity of this design. The loops connecting with each other make the mandala look lacy. When it came time to give it a name, the only thing that came to mind was *There* because I thought, *There, I'm done.*

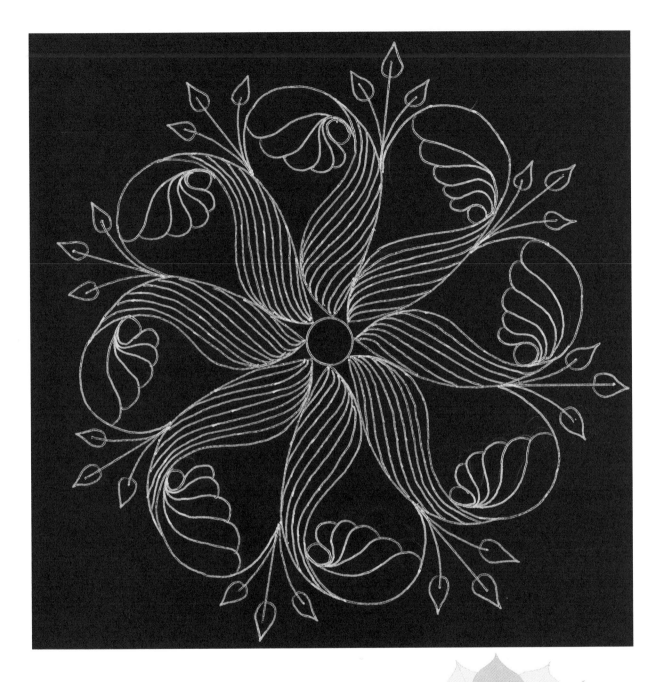

Weeping Willow

Here we have another white mandala design on a dark background. Once again, you can see how the simple white lines on black paper have a dramatic effect on the design. The way the loops hang over reminds me of a willow tree.

TRY LIGHT ON DARK

Try using black or dark background paper with simple line drawings using a white pen. Draw lines close and far apart and see what emerges from your design.

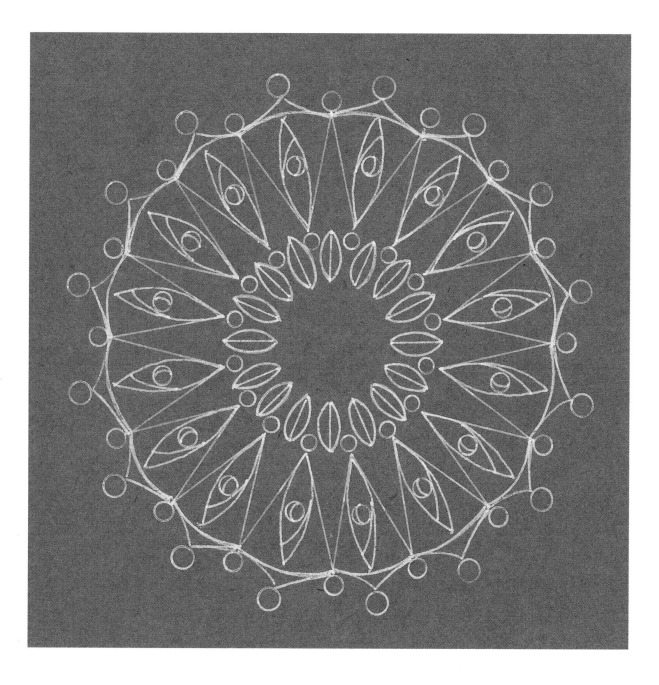

Eye of the Storm

Here is another mandala on tan cardstock, but this time I used a white pen and drew my favorite go-to pattern, leaves. This mandala has very simple lines and circles drawn around the leaf pattern. Although it is very open, the lines and circles fill it in just enough to make it interesting. The open circle in the center looks like the center of a tornado or twister. I have never personally seen one, but that is how I imagine one would look in the eye of the storm.

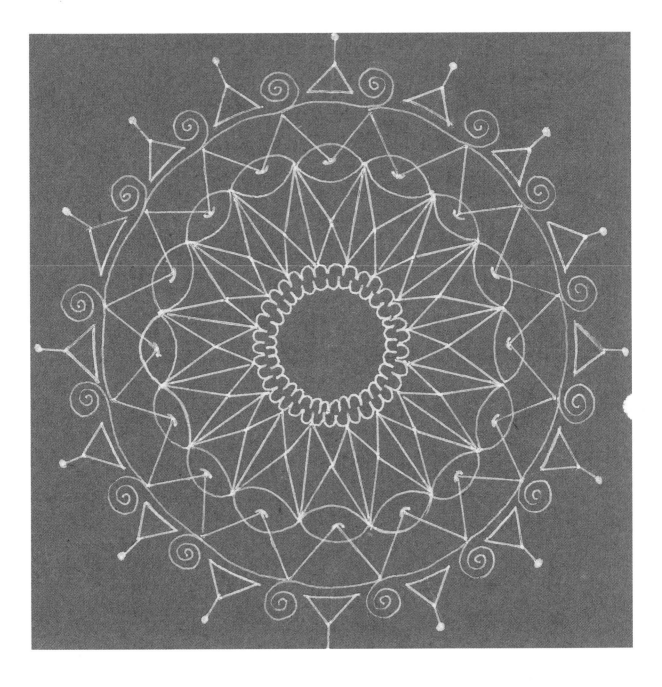

Circus Tent

Here I drew another mandala on tan cardstock using a white pen. With this mandala I used mostly triangles, lines and a few circles/ovals for my pattern. Unintentionally, the mandala ended up looking like a circus tent from a bird's-eye view. The triangles on the outside and the lines with dots look like stakes holding the ropes on the tent.

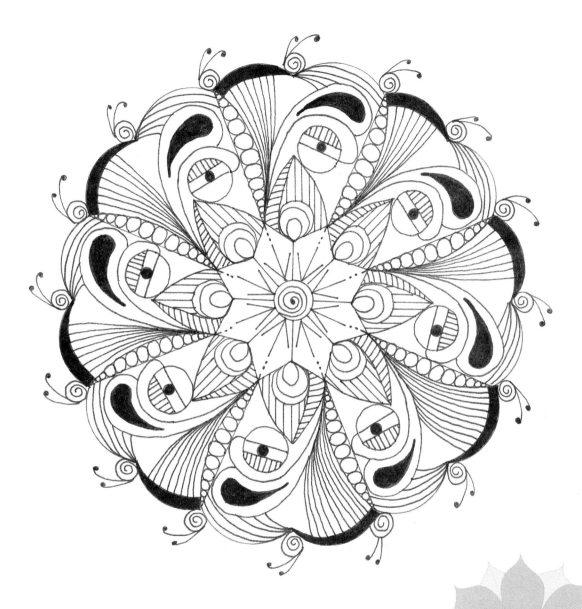

Snails' Pace

With each of the previous mandalas, I used mostly lines, keeping it simple. I want you to feel simplicity with a dramatic effect. Here, with *Snails' Pace*, I am still using mostly lines, but now I am adding more patterning, weighted lines and fill-ins. When I draw mandalas, the center seems to dictate how the mandala is going to end up. Each pattern tells me what the next one should be.

I have a signature pattern that I like to use frequently with my mandalas to finish them: swirled circles. This time I added little antennas and turned my swirled circles into snails moving around the mandala.

TAKE A BREAK

Sometimes, when I am stuck and I do not know what pattern to draw next, I walk away for a while or simply finish it the next day. You don't always have to finish a mandala in one sitting. It took the Old Masters a lot longer than one day to complete their masterpieces.

Visit CreateMixedMedia.com/creating-mandalas for extras.

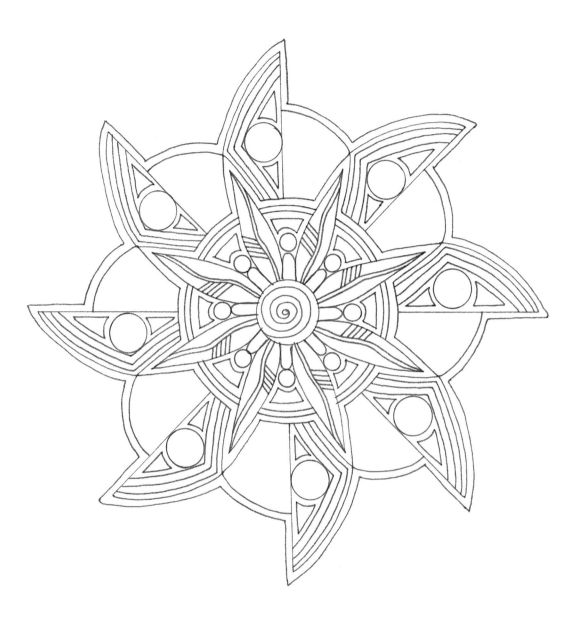

Michael

Creating mandalas is not only enjoyable, but it can be a great meditative pastime. Releasing that negative energy can turn into something positive and beautiful. For me, this mandala holds a deep personal meaning. I created it after my eldest son, Michael, passed away two days after Mother's Day. I drew this mandala to keep my mind occupied and to get me through a difficult time, and it did.

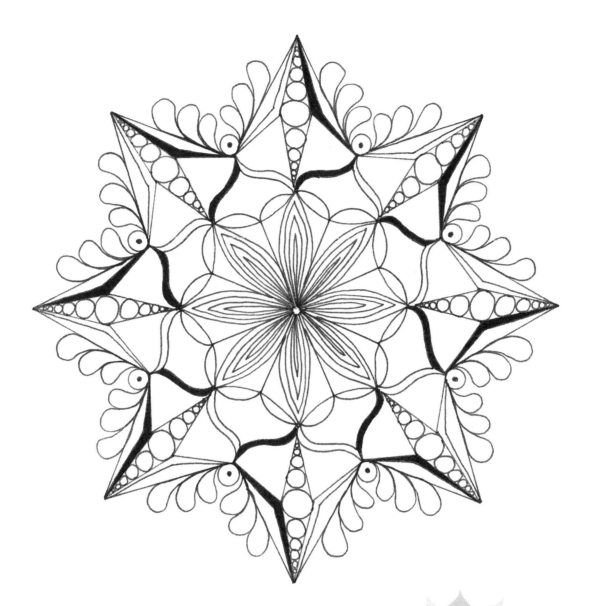

Soap Bubbles

This mandala reminds me of the song by Don Ho: "Tiny bubbles, in the wine, make me happy, make me feel fine." Am I dating myself? Anyway, when I finished drawing this, I saw a soap design—one that might be seen floating in water as it goes down the drain after washing dishes.

LET THE MUSIC MOVE YOU

Have music playing in the background as you create your mandala. The mood of the song can influence what you draw.

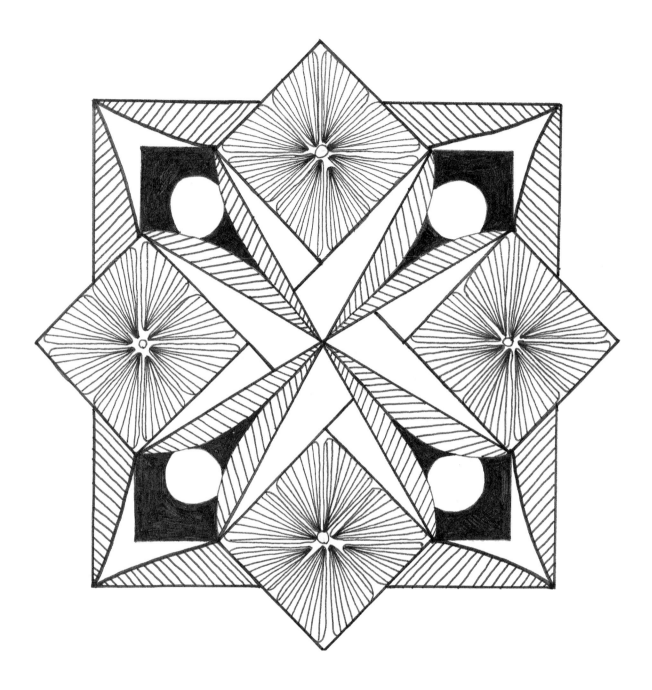

Towers

Traditionally mandalas are drawn round. I chose to start with a square with this mandala, adding diagonal squares around the perimeter of the square mandala. If you take a closer look, you can see that not all the lines that form the design are straight.

Have you ever seen a picture looking down onto a cityscape? This mandala reminds me of tall towers hovering over the landscape of a big city.

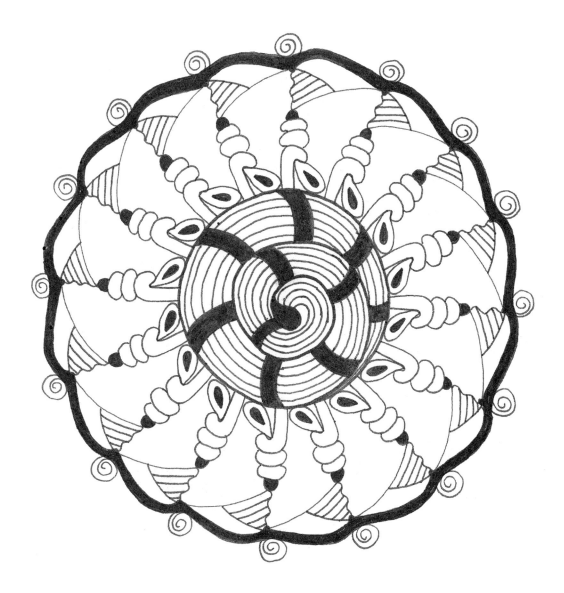

With a Cherry on Top

This mandala started with a candy swirl in the center and a modified version of the Tangle pattern Zinger. Instead of drawing a straight circle, I drew a slightly curved, weighted line around the outside. I finished the outside of the circle with my swirled circles. After I filled in the circles above the pattern, the Zinger looked like a cherry on top of a chocolate sundae.

Fans

The center is a flower pattern with lines added, and the filled-in shapes around the center flower mimic the indentation of each petal. The straight lines around the flower design ended up looking like fans around the mandala. Double curved triangles, with the inside triangle filled in and a petal shape in between, finished the mandala.

Optical Illusion

I already knew I was going to create a mandala that was going to be a flower in itself. I drew the Tangle pattern Aurkas for the center of this mandala. I wanted the pattern to be bold for this particular design. To separate the petals from the center design, I added circles around the center pattern. I must say, after finishing this mandala, it made me dizzy. As I looked at it, it seemed to be more of an optical illusion. It still makes me dizzy to look at it now.

Vector

The definition of vector is "a quantity having direction as well as magnitude, especially as determining the position of one point in space relative to another." I would say this mandala fits that description. To finish the mandala, I drew a square around it and divided the corners with triangles. Doing this made the center design pop.

Maise

The design for this mandala was already starting to take form in my head before I sat down to draw. I wanted the design to be a circle in a square with intersecting lines. The look was clean but empty and boring. I knew it needed more. With added lines, curves and angles, my mandala started to take on a maze look. So, there you have it: *Maise*.

 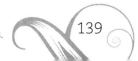

Daisy Do

To make this mandala, I used a snowflake pattern—a great way to get you started because all you have to do is trace around the open space and you have the start of your mandala (see the *Snowflakes* project in Chapter 6). I cut out a snowflake and traced around it on my paper. By connecting and/or deleting lines, I created this design from that snowflake pattern. The tips look like daisies that *do* want to spring out into the sunshine.

About the Author

DEBORAH A. PACÉ is an award-winning multi/mixed-media artist and workshop instructor. She is a Certified Zentangle Teacher and Sulky Instructor. Deborah has been published in two North Light Books, *Zen Doodle: Tons of Tangles* and *Zen Doodle: Oodles of Doodles*. She started in fashion at the age of twelve, and from there her interests and talents grew. She is not only a quilt artist and designer but a fiber artist as well. Along with quilting Deborah makes and sells her own jewelry and paper art. She is currently working on designing a Tangle pattern market bag for sale in the near future. Her interests are always growing, and she is always working and experimenting on new designs and learning new techniques. Deborah is a member of Quilt Visions, SAQA (Studio Art Quilt Associates) and WAC (Wearable Arts Connection). You can contact Deborah at **dpavcreations@gmail.com**, or visit her at her blog, **dpacreations.blogspot.com**.

Acknowledgments

First and foremost, I would like to thank God for the talents He gave me and the ability to use them; F+W for the opportunity to write this book; to my husband, Doug Pirie, for supporting me through all this and being ever so patient with me; and last, but not least, I would like to thank you, the reader, for purchasing my book.

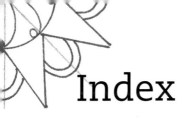

Index

Other fine North Light Books are available from your favorite bookstore, art supply store or online supplier. Visit our website at fwcommunity.com.

a content + ecommerce company

19 18 17 16 5 4 3 2

DISTRIBUTED IN CANADA BY FRASER DIRECT
100 Armstrong Avenue
Georgetown, ON, Canada L7G 5S4
Tel: (905) 877-4411

DISTRIBUTED IN THE U.K. AND EUROPE
BY F&W MEDIA INTERNATIONAL LTD
Brunel House, Forde Close, Newton Abbot, TQ12 4PU, UK
Tel: (+44) 1626 323200, Fax: (+44) 1626 323319
Email: enquiries@fwmedia.com

DISTRIBUTED IN AUSTRALIA BY CAPRICORN LINK
P.O. Box 704, S. Windsor NSW, 2756 Australia
Tel: (02) 4560-1600; Fax: (02) 4577 5288
Email: books@capricornlink.com.au

ISBN 13: 978-1-4403-4186-1

Edited by Kristy Conlin and Stefanie Laufersweiler
Designed by Geoff Raker
Production coordinated by Jennifer Bass

METRIC CONVERSION CHART

To convert	to	multiply by
Inches	Centimeters	2.54
Centimeters	Inches	0.4
Feet	Centimeters	30.5
Centimeters	Feet	0.03
Yards	Meters	0.9
Meters	Yards	1.1

zentangle®

ZENTANGLE®
WWW.ZENTANGLE.COM

The Zentangle method is a way of creating beautiful images from structured patterns. It is fun and relaxing. Almost anyone can use it to create beautiful images. Founded by Rick Roberts and Maria Thomas, the Zentangle method helps increase focus and creativity, provides artistic satisfaction along with an increased sense of personal well-being and is enjoyed all over this world across a wide range of skills, interests and ages. For more information, please visit the Zentangle website.

ABOUT ZENTANGLE®:

The name "Zentangle" is a registered trademark of Zentangle Inc. The red square logo, the terms "Anything is possible one stroke at a time," "Zentomology" and "Certified Zentangle Teacher (CZT)" are registered trademarks of Zentangle Inc. It is essential that before writing, blogging or creating Zentangle Inspired Art for publication or sale that you refer to the legal page of the Zentangle website.

www.zentangle.com

ZENTANGLE® PATTERNS FEATURED IN THIS BOOK INCLUDE:

Aurkas by CZT Molly Hollibaugh
Betweed by Maria Thomas & Rick Roberts
Fengle by Maria Thomas & Rick Roberts
Mooka by Maria Thomas & Rick Roberts
Paradox by Maria Thomas
Zinger by Maria Thomas

Ideas. Instruction. Inspiration.

Receive FREE downloadable bonus materials when you sign up for our free newsletter at **CreateMixedMedia.com**.

Find the latest issues of *Cloth Paper Scissors* on newsstands, or visit artistsnetwork.com.

These and other fine North Light products are available at your favorite art & craft retailer, bookstore or online supplier. Visit our websites at artistsnetwork.com and artistsnetwork.tv.

Follow CreateMixedMedia.com for the latest news, free wallpapers, free demos and chances to win FREE BOOKS!

Get your art in print!

Visit **CreateMixedMedia.com** for up-to-date information on *Incite* and other North Light competitions.